stratechic 2.0

Her Plan. Her Power. Her Purpose

stratechic 2.0

Her Plan. Her Power. Her Purpose

Michele Thornton Ghee

Published by Mynd Matters Publishing 201 17th Street NW, Suite 300, Atlanta, GA 30363 www.myndmatterspublishing.com
Library of Congress Control Number: 2017903657
ISBN-13 (paperback): 978-0-9899164-8-6
ISBN-13 (hardcover): 978-0-9981990-6-1

SECOND EDITION

Logo design by Brittney Dorsette

Printed in the United States of America

To my family,
Tony, Taylor, and Jordan
You inspire me daily to want more, be more,
and do more.

Thank You

FOREWORD

Strategy is power which is artfully conducted. Chic is the essence of the intuitive rich femme. When the two are combined, it is badass! Regardless of where you are on the badass sliding scale, each of us can learn from a **STRATECHIC** point of view; myself included! When people look at my résumé or hear of my accomplishments, they assume I must have all the problems solved and answers to everything. But that is not true. New experiences require new knowledge and I have been acquiring knowledge throughout my journey—both professionally and personally. I moved to the United States at age twelve and had to quickly adapt to a new environment. That prepared me for all of the challenges that would come my way.

As an executive in the marketing/advertising world and now one of few women executives in tech, strategy is a critical skill for me. **Stratechic** is the perfect tool with which to build my new experiences so that I can achieve my best. The chapter about self-awareness was so timely. I used it to help identify people in my life whose intentions were not positive or productive for me. Michele loves to say that it's okay to have people who aren't praying for you but it is not okay to have people in your circle that are praying *against* you. As a single mother (my husband Peter passed away), I also have to make sure all decisions are in the best interest of my family. I cannot afford major mistakes because I have too much at stake—and many women feel that same pressure. **Stratechic** is my resource for building out strategies at work,

building unbreakable personal relationships, not wavering when I ask for what I have earned, and a constant reminder that I must give back to fully leverage God's plan for my life. This book is a must-read for every woman, no matter her age, position, or badassness level. It's time for us to get what is meant for us. So, read this book. Build out your plan. And walk in your life's assignment. I am! Let's Go!

Bozoma "Badass" Saint John

CONTENTS

ACKNOWLEDGMENTS

Over the past year, I have been on the road meeting phenomenal women that all want to do the same thing: build "Her" plan, activate "Her" power and walk in "Her" purpose. *Stratechic 2.0* was born from the women I met on this journey. Like many of them, I have been played, taken advantage of, given my time and energy to undeserving people, worked hard without acknowledgement or promotion, afraid to ask for what I had earned, not know my brand or story and just made bad decisions over and over again.

My dad, Walt Thornton, who was such an inspiration through his hard work as an entrepreneur and sales professional. I made a promise to him on his deathbed that I would make him proud of me. I hope that I've kept my word. My mom, Francoise, who sacrificed her dreams so that I could pursue mine. I am eternally grateful to her and I share this dream of writing a book with her. My brother, David, he is my conscience. He is such a good man—a man of God. He has been on this journey with me as a reminder that I can do anything! I know what greatness and sacrifice look like because of my aunt, Dr. T's, commitment to education. I hope she knows her life has been an inspiration to me and all that I have achieved. Momalene, my grandmother, who taught me to stand on my own, be independent and that you are never too old to know and love God. My husband and kids—they inspire me every day to be better, walk with integrity and give back like I may need someone to give to

me one day. I hope they are as proud of me as I am of them. My Village - Joy, Nicole (Coco), Tiffany R, Tiffany B, Joni, Renee, Jackson, Bozoma, Shetellia, Tai, Vonny, Lynn and Lyte - These are my **Stratechics**! Every woman needs a posse of supporters that will tell her the truth! Thanks to my hair stylist, Will Robinson, who did my hair for the cover and once a week to keep me looking right! Joanna Simkin who did my make-up. A special thank you to Egami Consulting for hosting a **Stratechic** strategy session. A special shout out to Brittney Dorsette who encouraged me, created my logo, answered my phones and, most importantly, prayed for me along this journey!

"If you don't build your dream, someone will hire you to help build theirs!"

Tony A. Gaskin Jr.

PREFACE

"People are the most valuable known resource. The better they are crafted, the more valuable they are. Underutilized resources may result in greatness this world will never know. Waste not, want not."

-Brittney Dorsette

WHY DO WOMEN SPEND MORE TIME HELPING OTHERS BUILD THEIR DREAMS THAN BUILDING THEIR OWN? Trust me, that's a rhetorical question. I know exactly why. It's because most women are natural givers and nurturers. Those are some of our best characteristics. Women often ask me about balance. How do I balance my career, family and life? I shifted that question a bit and started asking how to balance my life's assignment and all that I do for other people. That simple change in thought process led me to write this book. It's a question I stress women to ask themselves as I plead with them to become more intentional about their lives. **Stratechic 2.0** gets to the heart of a mindset shift that puts women in control of their destiny.

Be an owner, not a renter.

My boss and one of my advisors, Louis Carr, loves to remind his management team that in business, it's important to have an owner's mentality. Owners invest in their businesses and think long-term. Unlike renters, owners are

fully invested and consistently give it their all. Renters rarely, if ever, give the same effort or attention to detail. Renting is temporary and focused on the short-term. In life, don't behave like a renter. Be an owner of your present and future. Invest fully. Be deliberate about what you do and how and with whom you do it. You must develop a plan; one you write down and execute.

"Write down the revelation and make it plain... so that a herald may run with it." (Habakkuk 2:2 NIV)

Ladies, we have to stop renting our space in this life while trying to fix everyone else's problems and taking ownership of others' lives. We owe ourselves the commitment of owning our choices and the future we create.

Often, we read books that tell us to feel good, be empowered, or live our best lives but don't provide a roadmap or a timeline to get it done. Every time I have a speaking engagement, I ask the audience how many times they've been to an event like the one they are attending. Typically, it's an annual event and most women have attended for back-to-back years. I ask what they've accomplished in the time between last year's and this year's event. Did they keep in contact with anyone? Do they even know the person's name sitting beside them? Time after time, women raise their hands and admit that not only did they fail to capitalize on opportunities presented in the room, they also didn't follow up with contacts and potential leads after the event. This is unacceptable! We have to stop wasting our time and opportunity and focus on walking in God's true assignment for our lives.

Stratechic was born from a need to help women be more strategic and not make these kinds of mistakes. It's a step-by-step framework that helps all women operate at their best. The process takes time and commitment and will not happen overnight. However, through PURPOSE, INTENTION and PRACTICE, you will build a *Stratechic* plan to walk in your true assignment!

The heart of a man plans his way, but the Lord establishes his steps.

Proverbs 16:9

The heart of a woman PLANS Her way, but the Lord establishes Her steps.

Stratechic

"If we don't change, we
don't grow. If we don't grow,
we really aren't living."

Gail Sheehy

INTRODUCTION

I grew up in Oakland, California. The daughter of two parents who worked hard, I had a good childhood. We weren't rich, but we weren't poor either. My parents sent me to decent schools and I was a strong B student and an athlete. I played basketball through my junior year of high school but losing my love for the game resulted in my not playing during my senior year. Choosing not to play was one of the primary reasons I didn't go to college right away. When I think back, I can admit to feeling like somewhat of a failure. My friends were all preparing to leave for different colleges and I didn't even fill out one application. I was following the path of both of my parents, neither of whom had a traditional college experience.

After high school, I was approached by a neighbor who offered me a job at a local naval base. The job paid $25/hour. There was no way I could turn down that offer. Little did I know, the neighbor who offered me the job had different intentions than boss and employee. When I didn't accept his advances, he moved me to a department that was grueling. I hated my job but couldn't walk away from the money because I became accustomed to the lifestyle it provided. I had also amassed credit card debt and a car payment. When I could no longer take it, I made up my mind to quit. I can't tell you how many people told me to "hang in there" because it was a "good government job". I was a risk-taker then and I'm still one today. I finally walked away from that job. There were some sacrifices and some lessons learned but it was a

wise decision and had a big payoff in the end.

During my tenure at the naval base, I met a man and fell in love. You know the story. I began living for the next date or call that didn't come as often as I wanted. I was likely filling the void of not spending enough time with my father growing up. He worked seven days a week, fourteen hours a day. We rarely did much as a family and even less as father and daughter. My mom was the one constant in my life and I love her for it. This isn't to say my father was a bad person. However, it simply explains why I made certain decisions growing up.

At this point, I didn't have a college degree, hated my job, was in a bad relationship, lived at home with my dad (my mom moved back to Canada to care for her elderly parents), and had no concrete plans for my future. On my 21st birthday, I decided something had to change. As fate would have it, later that year I was introduced to a successful guy who played in the NBA. We began dating and I finally realized why I was born: to be HIS wife. *Don't judge me, I was young, silly, and didn't love myself!* Ladies, how many of you have decided what your own destiny looks like? I can tell you it is a dangerous thing to invoke your own will. From ages twenty-one through twenty-five, I lived my life through someone else's dreams and successes. I made sure I was available emotionally and physically for someone else's benefit. This was unacceptable then and it is absolutely unacceptable today.

I remember the precise moment I decided to walk in the destiny that was designed for me but I had been failing to grasp (not the one that I had manufactured, but the one

I was actually born for). Clarity came when I realized I was NOT created to be arm candy, a side piece or whatever you would call a woman dating men because she doesn't love herself. I was operating in an adult world, dating through the lens of a young girl constantly seeking affection from men because of the void from a father's love—a father whose presence only lacked because he worked day and night to provide for his family.

I haven't told many people this but I was about twenty-five years old and extremely unhappy with my life and circumstances. I was in a horrible relationship, had no direction, and very little education. It was crazy because people would look at me and actually envy my life. One night, I had a dream. I was driving my boyfriend's Porsche across the Bay Bridge. The road was littered with potholes and I was doing my best to avoid them. Finally, I pulled over and got out of the car. When I stepped out, God was standing in front of me. Although He didn't speak one word, I knew he was rightly disappointed in me and my choices. I dropped to my knees, cried and prayed, asked Him to change me, and to change my life. When I awoke, I recalled every detail of the dream.

Shortly thereafter, I enrolled in school, my relationship ended, and I began to live differently. I made sacrifices. I no longer had financial support from a boyfriend. Instead, I took care of myself by cleaning houses and working at the front desk of a hotel. Unfortunately, I also gained thirty pounds because I didn't have time to make smart food choices.

Through it all, God directed me. He whispered that there was something better for my life—a different path.

We have to sacrifice and walk in the valley to appreciate the journey to the mountaintop. Although I haven't arrived, I'm reassured that I will make it.

The essence of **Stratechic** is to remind and reaffirm that each of us can reach our mountaintop. We can overcome all setbacks and challenges to reach our goals. It won't always be easy but it will definitely be worth it! In this book, I share the 10 strategies that have made me a *"Stratechic."* As you commit to this process, write out your action plan after the appropriate chapters. This book provides you with a clear framework and the corresponding tools to help you build your roadmap for change. I am 100% confident that writing out your plan and vision, things you want and need to change, will result in you taking action towards the goals you've set.

I once attended Harvard for an International Women's Leadership Executive Program. The first day of class, women from twenty different countries descended upon the class equipped to learn. We all pulled out our computers and iPads poised and ready to take notes. The instructor politely told all of us to put away our electronic gadgets and to take out a pen and paper. She confidently told us that when we write out our thoughts, we begin to build a relationship with the words written and they are forged into our psyche.

I will also introduce you to the results of an in-depth 2015 Women & Strategy Research Study I commissioned via a third-party agency. The study was comprised of entrepreneurs, entertainers, wives, community leaders, business executives, stay-at-home moms, and everything in between. They are influencers within their homes,

communities, networks, and organizations. While the majority may never wear the title of CEO, I've learned that most people who influence change don't require a title.

GREATEST THING THAT'S EVER HAPPENED TO ME

I've worked in the media and entertainment industry for the past fifteen years. In the last three years, I've been promoted to the senior executive team as the Senior Vice President of Media Sales for BET Her (formerly known as Centric TV, "The First Network Designed for Black Women.") There are very few women who lead sales organizations and even fewer Black women. I can wholeheartedly say I love my job and my company! I've taken so many of the principles learned in my twenty plus years as a sales professional and applied them to my strategy.

To continue to grow the revenue stream for our network, strategy is critical to our team's operation. I quickly realized, once I put a strategy together for my life, everything improved, both personally and professionally. Bozoma Saint John, a good friend that also wrote the foreword for *Stratechic 2.0*, often uses the phrase, "Let's Go!" She uses it to remind herself how important it is to get up when a personal tragedy strikes and knocks you down. She is the ultimate *Stratechic*. But I'm getting ahead of myself.

I have listed what this book is but let me also tell you a bit about what it is not. This is NOT a book for someone looking to simply feel good or feel empowered. This is NOT a book to get over a bad relationship, anger at a lost promotion, or a quick fix for all the things you don't like in your current station in life. So many things in our lives are for, or because of, someone else. This book is a gift to *us*.

I've read that 80% of women don't ask for what they've earned. Not what they want, but what they've actually earned. I was at a women's conference and the facilitator asked us to participate in an exercise. We were directed to share with the people sitting next to us the best thing that's ever happened to us. The young lady sitting beside me went first as she was so excited to share her story. She had just given her grandfather a 75th birthday party. It took months to plan and it was a huge success. I was sitting there staring at her (hopefully not with my mouth open). It hit me like a ton of bricks that for most women, the best thing that happens to us is something we do for someone else. Please take a minute to digest this, as it is a key point and the foundation for everything found within these pages. One of the best qualities we have as women is our giving and nurturing spirit. *Stratechic 2.0* is a manual for taking that God-given trait all women possess and leveraging it to begin our transformation into strategists.

Let's make a commitment today that the best thing that happens to us is NOT something we have done for someone else but something we do for ourselves.

The Greatest Thing That's Happened to Me Exercise (30 minutes):

Before we continue, let's put things into perspective. Make a list of the following:

✓ the greatest thing that has ever happened to you

✓ the greatest thing you have done for yourself

✓ the greatest thing you have done for others

Feel free to include several items within each list. My lists are provided below for guidance.

The Greatest Thing That's Ever Happened to Me:

- ✓ I'm a wife and mother
- ✓ Realized God loved me before I could love myself
- ✓ Received an Honorary Doctorate of Human Letters from my alma mater, Golden Gate University
- ✓ Self-awareness became part of my daily habits
- ✓ I've built unconditional relationships
- ✓ Received numerous awards from some amazing organizations

The Greatest Thing I've Done for Myself:

- ✓ Moved to New York to work in the television business
- ✓ Love myself unconditionally
- ✓ Graduated from college at 30 years old
- ✓ Understand I am the master of my happiness
- ✓ Not allow people to steal my joy
- ✓ Learned to accept help from others
- ✓ Hired a voice and diction coach

The Greatest Thing I've Done for Others:

- ✓ Cared for my dad during his bout with leukemia

✓ Support children and youth causes

✓ Tell people the truth at all times

✓ Raise money for various foundations

✓ Inspire and motivate others through my actions

✓ Create diversity opportunities for others in the media business

✓ Advocate for women around the world

Hopefully, this exercise provides clarity. We often confuse the greatest thing that's happened to us with the greatest thing we've done for others. Let's unblur the lines to ensure they are categorized appropriately in our lives. We must recognize the things we do for others as just that. When we get **Stratechic**, we become more intentional about our time and energy. We think about them as investments. To whom are we investing our time? How much time and energy are we investing in certain people and activities and are they even worth it? What's the purpose for our investment? More importantly, we begin to understand the significance of doing things for ourselves because we deserve it. For many women wearing multiple hats and filling countless roles, if we do not do it for ourselves, it won't happen!

I recently hosted a **Stratechic** playbook session and asked someone in the audience to share the greatest thing they have done for themselves. A young lady tearfully stood up and said, "The greatest thing I've done for myself is have a son." I thought about her response before I gave her my feedback. I told her that's absolutely one of the greatest

things that's happened to her. My question was what's one of the greatest things that she had done for herself? Had she started her own business? Did she end a relationship that wasn't worthy of her time and love? Did she recently lose weight and decide to live a healthy lifestyle? These are things that we have the power to do for ourselves. This mindset shift must be part of our overall plan to be our best selves. We have to stop allowing people to make more withdrawals than deposits before we become emotionally and mentally bankrupt.

WOMEN & STRATEGY

If I could put flashing lights on this page, I would. Largely because this chapter is so important and I don't want anyone to skip it! Strategy is not a word often used for or about women. When I searched "women and strategy," there was nothing specific that jumped off the pages. Nothing? Really. Wow. I was disappointed but not surprised. Although books are readily available on empowerment, love, fitness, finance, and leadership, strategy is the necessary tool for each of those topics and frameworks.

So, what is the official definition of strategy?
Strategy: a careful plan or method for achieving a particular goal, usually over a long period of time.

Merriam-Webster's Dictionary states the first known use of strategy in 1810. However, other sources note origination in the 6th century as a military term. Generals instituted strategies to win wars and protect the world. Regardless of the source, there are no feminine connotations associated with the meaning of strategy—at least not in the definition's purest form.

Throughout these pages, I address strategy as it relates to women. Our common definition for strategy, in this sense, is when a woman carefully designs or plans to serve a particular purpose in her life and to capitalize on the qualities with which she was born.

The beauty of being a *Stratechic* is that you do not have to act or think like a man!

Instead, use all the power and gifts you inherently have as a woman. Three common themes from the women's definition of "strategic" in the 2015 research study were:

1. Having clearly defined goals that you work toward

2. Having long-term vision and being intentional about planning

3. Not focusing too much on the short-term

Let's break down those definitions:

Strategic: Carefully designed or planned to serve a particular purpose or advantage.

***Stratechic*: When "women" carefully design or plan to serve a particular purpose or advantage for their lives!**

Having this mindset is integral for all women. I consistently interact with women that are NOT *Stratechics*. They do not plan or design their future. They live like renters and not owners. They only plan their next outfit, vacation, job, diet, or boyfriend, but not an overall strategy for life. The dirty little secret is that women are born strategists. At a very early age, we have to learn how to manage the playground with other girls, manage group dynamics in middle school, and deal with all of the decisions around dating and colleges to attend. Then, we grow up and have careers and families. I multitask on a daily basis to juggle the demands of career

and family.

Everyone has a moment in his or her life that is life-changing. It is a small voice gently urging you to follow a course that puts you on a path to your destiny. But...

Most Of Us Cannot Hear The Voice Because We Are Too Busy And There Is Too Much Noise Around Us!

Stratechic is about learning how to course-correct your life with intentional planning and execution. The lessons on these pages are designed to help you learn from mistakes and listen to that small voice whispering (and sometimes yelling) your name. The voice that only has your name and destiny in mind when it speaks. This book awakens that female intuition that says, I have not done my best, I am not walking in my true assignment, and I have no plan of action. A *Stratechic* doesn't just create a vision board. She maps out a plan so that the vison board becomes more than another piece of artwork on her wall! Ladies, this book is real talk because we are fighting for our destiny. When we begin to walk in our destiny, everyone in our path benefits.

Stratechic 2.0 doesn't just force you to think, it demands you to put those thoughts into an action plan, helps you identify allies, and requires a time stamp for clarity. A plan means nothing without execution! It means you have to create a strategy, a plan for you to live your best life. The good news is that women are born with all of the characteristics to be strategists. We just don't always take the time to tap into our inherent qualities. Or, we've gotten comfortable using our time and energy to help others live their best lives. In the words of Bozoma, *Let's Go!*

LESSONS FROM THE 4TH GRADE (FROM MY DAUGHTER)

I've been contemplating writing this book for the last five years. I've always wanted to share what I've learned along the path of my life and career that helped me navigate Corporate America and better yet, life as a whole. I attended conference after conference trying to figure out what's next. I would go, hoping to hear something that would change my life for the better and instantly transform me into greatness. I would watch the speakers knowing that I could also stand on a stage and deliver a powerful message. One day it hit me that most of the speakers were introduced as authors. Aha! So, there was a price of entry into the world of public speaking. The path to least resistance was to write a book. Then the question became, what do I write about?

Suddenly, there was one defining moment that clarified my path and direction. I knew I had to write a book on strategy when a fellow mom at my children's school told me that the strategies I was teaching my daughter would never work long-term. Isn't it amazing how things are born and become clear? All of the things I had experienced were crystalized in this one small exchange! I find it interesting that giving my daughter advice (she was ten years old at the time) about loving herself and not letting others define her is called a strategy.

My daughter had a disagreement with a classmate. The next day the young lady brought in bracelets for the girls in the class except my daughter. She looked my daughter

in her face and said, "Sorry, I don't have enough for you." I travel across the United States and never bring anything back for my daughter's friends because I don't want to make anyone feel left out. I called the girl's mom and respectfully explained that it is not appropriate to leave out one girl. She told me that I should just stay out of it and that the oversight was not intentional because, "her daughter doesn't have a mean bone in her body." I will discuss self-awareness in another chapter so hold that thought. My daughter said she didn't care. However, I cared and it was a great opportunity to hold a strategy session! LOL. After my daughter gave me a description of the bracelets, she told me that they are sold at Toys R Us. I looked at the clock. It was 9:07 PM and the store closed at 9:30 PM. I jumped in my car and ran to the store. I bought two kits. As my daughter and I built the bracelets (it was a do-it-yourself kit…Ugh!), I laid out the strategy. I told her to follow the plan exactly as I explained. The next day at school, she was to wear the new bracelets. She had to wear a short sleeve blouse so that the bracelets were noticeable. If anyone knows me, they know we made multiple bracelets of various colors and shapes. When she got to school, she was NOT to say one word about the bracelets unless asked about them. Of course, it did not take long for the other girls to notice the bracelets and inform the classmate that my daughter had them on. Finally, the young lady approached her and offered her a bracelet. It's funny how people want to give you something when they see you already have it. My daughter politely declined. Then the question came that we were anticipating. "Where did you get those bracelets?" My daughter was honored to say the words my grandmother had

taught me. "When someone doesn't want to do something for you, you have the power to do it for yourself!"

The lesson is not about outspending or one-upping someone else. It is about understanding that no one can control you unless you give them permission. Not only did my daughter learn a valuable lesson, this situation helped create my sense of urgency for this book. I'm proud to share strategies in *Stratechic 2.0* that are applicable in a classroom, boardroom, and every room in between.

Stratechic 2.0 is designed to help women cultivate their female instincts to build a strategy for their lives. It is a call-to-action when people say you're not qualified, you won't win, you'll never graduate, you'll never get married or have a satisfying relationship, or you'll never fit into that size again. In truth, having a plan and executing against that plan is the best revenge for negativity. *Stratechic 2.0* will help you crystallize a path forward no matter your circumstances. The preparation is very personal for each of us but the equation or formula is the same. These ten pillars will prepare you for any situation and help you towards becoming your "personal best." The attributes I present will fuel you for every good thing you want to happen.

This process takes intentional planning, discipline and execution. Every good plan has to have a timeline and the courage to complete the goal. Throughout the chapters, you'll learn more about each *Stratechic* pillar and a recommended deadline to ensure constant progression. Using milestones and having a pre-determined timetable has served me well as a media executive, wife, mother, and change agent. Overcoming obstacles and enjoying success were all possible

through development and application of these steps.

Timeline Exercise (30 minutes):

"Time is the foundation for greatness."

<div align="right">Victor Uzoma</div>

You won't know where to go unless you know where you've been. I needed to better understand my life and all of the things that had led to me my current state. I decided to create a personal timeline of my life. Creating a timeline helps map out a path forward and humble your walk in the process. When I created my timeline, I realized that over the years I had spent a lot of time and energy on things and people that did not matter. I went from job to job in the same position, just at a different company and wasted energy that could have been used to focus on my life's assignment.

Take 30 minutes to create your timeline. During this exercise, I ask that you be extremely thoughtful and factual about where and how you've spent your life. I recommend doing it in one, five or ten year blocks. This gives you enough of a picture to see where time has been well spent versus wasted and clarifies your path forward. The good news is that we don't have to waste anymore time and God is absolutely willing and waiting to help us course-correct our path.

(reference My Personal Timeline next page)

My Personal Timeline

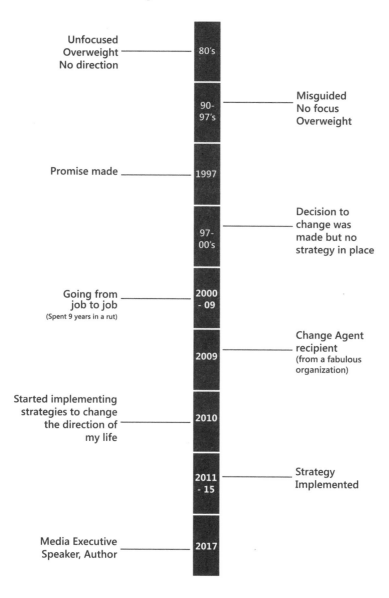

Unfocused Overweight No direction —— 80's

90-97's —— **Misguided No focus Overweight**

Promise made —— 1997

97-00's —— **Decision to change was made but no strategy in place**

Going from job to job (Spent 9 years in a rut) —— 2000-09

2009 —— **Change Agent recipient** (from a fabulous organization)

Started implementing strategies to change the direction of my life —— 2010

2011-15 —— **Strategy Implemented**

Media Executive Speaker, Author —— 2017

By now, you should have evaluated the best thing that's ever happened to you and created your timeline. Both of these are considered 'awareness tactics' with the primary function of driving motivation. For many of you, you'll complete the two exercises and quickly see how much of your lives have been spent focused on the wants and needs of others. My desire is for you to now say, "the best thing that happens to me will be for and about me!" The exercise also helps you put your life into perspective. The past is just that, a reflection of what has happened but it doesn't have to be a mirror to what will be.

The following chapters will be spent empowering you to do something for yourself now that you are acutely aware of the time you may have already wasted. It is time to develop a plan for your life. This book will guide you to become a **Stratechic** and transform your life into the woman God created!

Before jumping into the ten **Stratechic** pillars, you must complete one last exercise. Let's evaluate how we spend most of our time. This will be very important because without the appropriate time allocation, you can't make anything happen.

First, create a pie chart or a graph showing how you spend your time in a typical day. It's vital that you are brutally honest with yourself. I tried writing down how I spend my day from memory but I didn't do a very good job. The best way to track how you spend your time is to log your activities for a week. It will allow you to better see what patterns exist. Once you see what your typical day looks like, map it on a 24-hour clock. I guarantee you there are things

and people you are spending time with that haven't earned the right to even be in your presence! This is where it gets very real. Those things and people have got to be eliminated. Ready? Let's take a look.

An Example of My Typical Day

12:00 AM – 06:30 AM	Sleep
06:30 AM – 07:00 AM	Wake up/Get the kids up
07:00 AM – 08:00 AM	Get dressed
08:00 AM – 09:00 AM	Commute to work/ Send emails/Read News
09:00 AM – 09:15 AM	Arrive at work
09:15 AM – 07:00 PM	Work
07:00 PM – 08:00 PM	Commute home
08:00 PM – 09:30 PM	Spend time with family
09:30 PM – 11:30 PM	Clean up/Organize/ Surf the internet/Create to-do list for the next day
11:30 PM – 12:00 AM	Me Time

**DO NOT READ ANY FURTHER UNTIL
YOU COMPLETE THE TIMELINE
AND TYPICAL DAY EXERCISES!**

I realized I could not change anything with a schedule like that! Something had to give. But many of you have similar routines. I already know the excuses that have entered your mind. They start with being too busy. You have to take care of your family. You have too much on your plate at work. Your organization and your community need you. You're sick, overweight and need to go to the gym but don't have time. There is an unending list of things that pop into your head and fill your daily schedule. Regardless, it's time to embrace the truth. It's time to stop making excuses. Stop putting everyone ahead of yourself. It takes extreme discipline and focus on God's will for your life. It takes a no-guilt policy.

When I decided to write my first book, I made a commitment to dedicate adequate time to the process. That included writing for at least one hour, four nights a week, as well as on my morning bus commute to work. Because I have to travel often, I worked on my book every time I stepped onto an airplane. I also had a very candid conversation with my family about the journey I was about to embark upon. I asked if they would support me even if it meant that I would occasionally have to sacrifice time with them. I knew that success is about setting expectations of those that depend on you most. My family has been extremely supportive and my children said, *"Yes mommy, let's go!"*

Earlier this year, I was sharing my story with a very influential group of women. One of the attendees (who is also a friend) brought her sister who is a full-time mom. I didn't realize it at the time but the session struck a chord with her. The attendee shared that her sister had experienced a

meltdown. She realized that she had made so many sacrifices for everyone else and now that her kids are in college, she has no idea what she is going to do with the rest of her life. Shifting your thinking is a very emotional process. Many women have spent years pouring into others only to find themselves feeling depleted, alone, and confused.

Because of that story and so many others, I was determined to provide more information and insight in **Stratechic 2.0**. I followed the same process and was very disciplined about updating the content because the women I've talked to and learned from deserve more. This experience and this process for change is an ongoing life lesson.

Years ago, when I was trying to get back into shape, I would leave work early (6:15 P.M. instead of 7:00 P.M.) and go to the gym for forty-five minutes three nights a week. I was committed and dedicated to changing. In order to change, you must be aware of how your current time is spent and then focus to make changes based on your needs and goals. My experience has taught me that if we can carve out just one hour for ourselves each day, we can make miracles happen! No matter what it is that we want to accomplish, "time is the foundation for success."

Stratechic Rule #1

SELF-AWARENESS IS BIGGER THAN KNOWING YOURSELF

(90 DAYS)

"Knowing yourself is the beginning of all wisdom."

Aristotle

"Knowing how others perceive you is a gift from God."

Stratechic

"Self-awareness is a clear understanding of your personality and how others perceive you." It is an essential tool for successful leadership and a trait all good managers should strive to attain."

The Generator Group

Self-awareness is critical whether you are eighteen years old and just beginning, reinventing yourself at age sixty, or any age in between. It is the first step to becoming **Stratechic**. Remember, a **Stratechic** uses her innate ability to create the perfect plan for her life and then executes like only a woman can.

This chapter forces you to not only look in the mirror, but also at your surroundings. Not everyone is prepared to be honest about what they see staring back at them. Until you are ready for the truth and admit you want to take action to improve your current situation, you do not need to read this book. Give it to a friend that has potential for greatness.

There are two goals for this chapter. The first is for you to better understand who you are today. Once you have an understanding of who you are (whether you like that person or not), that will allow you to pay attention to your surroundings. Then you will begin to understand how others see you. This is the second goal. Both are integral to success.

THE IMPORTANCE OF SELF-AWARENESS

A young lady once came to me for advice. She wanted to know why she was not getting promoted. I knew she was very smart and capable because she had helped me with several

projects. She sat in my office wearing too much makeup and a very tight dress that showed way too much cleavage. Most people will never tell us the truth, even when we ask. We worked for a very conservative company. I was sitting there thinking, "she has no self-awareness." She had no idea who she was or how her environment (peers and leaders) viewed her. That kind of blind spot was fatal. Unfortunately, she never got promoted and finally left the company.

A July 2013 Generator Group survey of 75 members of the Stanford Graduate School of Business Advisory Council rated self-awareness as the most important competency for leaders to develop. Leaders who foster self-awareness develop tools for leveraging their strengths and confronting their weaknesses. They earn credibility and cultivate relationships based on trust and respect. In addition, they remain open to new ideas, inquiries, and constructive criticism. This is applicable to all women whether you are a CEO, self-employed, schoolteacher, or stay-at-home mom. It runs the female spectrum.

Research by Hay Group, culled from its 17,000-person behavioral competency database in 2012, found that when it comes to empathy, influence, and the ability to manage conflicts at the executive level, women show more skill than men. Specifically, women are more likely to show empathy as a strength, demonstrate strong ability in conflict management, show skills in influence, and have a sense of self-awareness. Roughly half of the women in the Women & Strategy Study proactively seek feedback about strengths & weaknesses once a month or more. Eighty percent proactively seek it at least once a quarter.

When was the last time you took a real assessment of yourself? I want you to take a selfie of yourself and really look at the picture. I'm serious, stop reading for a minute and take the picture. It does not matter if you don't have on make-up and are wearing your most comfy clothes. We can't hide from ourselves—not in this exercise. Honesty is critical before we can change our current situation.

Ask yourself the following questions:

✓ Who am I?

✓ Do I like what I see?

✓ Can I be better?

More importantly:

✓ What are people's perceptions of me?

Those questions all lead to who I am currently, who I want to be, and how I want people to see me. That's fairly easy to say but much harder to uncover, especially since we've been told over and over again that you shouldn't care what other people think. Well, that's partially true. You can't win unless you know what others think and not knowing puts you at a disadvantage. The winner of the game understands that you can't give energy to the process.

I don't own what people think of me; I own having the knowledge so I can leverage that knowledge to my benefit. Knowledge is definitely power!

How did I go from an uneducated, unemployed,

overweight young woman with no vision to be an executive, author, speaker, wife, mom, and community activist? I listened to that small voice that said, "I created you for better," and then implemented the strategies in this book. Today, I am whispering to you, no matter where you are in your walk, you were created for bigger and better. You can be better. It absolutely begins with self-reflection. My transformation took sacrifice, honesty and a commitment to a bigger goal. Let's begin to outline the steps. At 26, I did not have a college degree, lived at home with my dad, had low self-esteem, and was thirty pounds overweight. The first thing I did was spend time self-reflecting and I wrote down answers to these questions:

✓ What do I enjoy?

✓ What makes me happy?

✓ What do I dislike about myself?

Then, I wrote down a few examples of my personal attributes:

✓ Do I smile or frown?

✓ Do I slump or sit up straight?

✓ Do I have a firm or limp handshake?

✓ Do I have a positive attitude?

✓ Do I speak to people when I'm walking down the street?

✓ How do I feel when a homeless person asks me for money? Do I give it to him/her?

You cannot meaningfully change or grow until you acknowledge and accept who you are. *What questions should you ask and answer for yourself?* Next, I noted the characteristics I liked and did not like. I took the information and began to modify my attitude and behavior. The bottom line is that I did not think about how someone else would have written my list nor did I discuss my answers with others. I actually got a pen and paper and wrote it out. I began to pay attention to how people treated and reacted to me. It is amazing what we learn when we focus. I uncovered that people would watch me in different scenarios. They would pay attention when I spoke. I realized that I was a people person. When I smiled at people and said good morning, most responded to me. I became happier and more confident.

To move my station in life, I had to make some changes. For example, my first big For example, my first big deficiency was not having a college degree. Many jobs today use education to filter candidates. I'd done well in school but knew I had to go back to advance my life and career. I had no idea what I wanted to do for a living but knew I needed options. You have to understand the barriers in your life and make the necessary plans to change them.

✓ What are your barriers?

✓ Who or what is holding you back?

I enrolled in school and got a part-time job. It was better to earn a small amount of money than to be in a bad relationship and not feel good about myself. Because of my late start, I didn't graduate until I was 30 years old. When I finally graduated from Golden Gate University, I was able

to get a job, not my dream job, but a good job. Always remember that self-awareness is a continuous process. That job was in Finance. Although it wasn't my dream job, it was a far cry from cleaning houses and working at the front desk of a hotel. Mind you, both of those jobs are respectable. However, I knew I was working beneath my ability. We have all been there. My job in Finance paid more but still wasn't fulfilling.

The second and maybe more important aspect of self-awareness also allows you to understand who is not in your corner. I lived in New York for three years and was really excited about interviewing for a new job at a reputable entertainment network. The job would be a big step in terms of responsibility and compensation. After several interviews, I was asked to supply the hiring manager with three references. I was confident in asking three of my best clients to vouch for me if called about the opportunity. At the end of the process, I was offered the job and had a very successful career at that network. I kept in touch with the gentleman who hired me. A couple of years ago, we went out to lunch (by that time, both of us had left the network). As we were catching up and reminiscing, he looked at me and said, "Michele, remember when I hired you? I hired you despite receiving a really bad referral from one of the clients you listed as a reference." What???? I was shocked. I mean, really shocked. I had vetted my references and actually spoke to them prior to including them on my application. Had I invoked self-awareness, I would have never listed a person who had been nothing more than cordial to me. He would always cancel meetings at the last minute, never accepted

meetings outside of the office, and would take several days to follow up with me. I was viewing our relationship through the lens of the service that I had provided to the business not his lack of response to my hard work and commitment. I didn't read the signs. It was a huge lesson and that has never happened again.

What's sad is that sometimes people will try to block your success for no apparent reason. My old approach to people who did not like me (or, as I affectionately call them, "haters") was screw them. Through maturity and growth in my faith, I realized that enemies take too much energy. Did I just quote Drake? LOL! I won't allow anyone to distract me from my mission to reach my full potential. The worst thing is to let someone bring out a bad attitude. It carries a stigma over your head for a long time and might prevent you from getting what is rightfully yours.

So how do you shake that gut feeling that you're selling out or being disrespected when you speak to someone you absolutely know has negative intentions for you? You ask yourself, why do they dislike me? Why are they blocking me? The answer doesn't matter when I know that every roadblock I ever encountered was blocking me from something great. Now, when there aren't adversaries, I start to get worried that progress isn't being made.

Before my dad passed away, he told me, "If you don't have enemies, blockers, or haters, you're not doing enough. You're not successful enough." I've seen so many people angry and mad because they aren't getting what they want at work, school or in a relationship. They are not self-aware enough to know that they have now given people a valid reason to

never elevate them. She has a bad attitude. She's not a team player. She's emotional (don't you love that one). Oh, and my favorite, she's angry. Yes, you have a reason to be all of those things but the trick is not to let anyone see it. Ever! There's a different set of rules for women and emotional displays are a huge excuse for people to put women in a no-progress/no-promotion bucket.

Self-awareness, the first **Stratechic** step, is time-consuming but essential. With it, you can evaluate where you are and where you want to go. That clarity will expose your abilities and shortcomings and allow you to understand how to *stratechically* manage your daily interactions and personal relationships to your benefit.

Self-Awareness Checklist (2 hours):

✓ What are my best qualities?

✓ What adjectives describe me?

✓ What do people think of me? How do I know?

✓ Ask people, "How am I doing at work/school/home?"

✓ How can I improve?

✓ Who are my advocates?

✓ Who can I confidently add to my reference list?

✓ Who do I want to be?

✓ What steps can I take to get there? How long will it

take (be realistic)?

✓ Who are the people that can help me get there?

✓ Who is on my enemy watch list?

✓ Who am I going to add to my prayer list?

✓ Who is praying against me and my progress?

Stratechic Rule #2

TRANSFORMATION STARTS
WITH YOUR CIRCLE

(180 DAYS)

"I have always known that if
you want to be successful at
anything you do in life, you have to
surround yourself with the people
that are good at it. Training with
champions makes you one."

Nik Lentz

It takes a village.

Surround yourself with people who can continually tell you the truth about yourself! They may not be praying for you but you are absolutely positive they ARE NOT praying against you.

Before my father passed away, he shared many important lessons. One day, I noticed him staring at me from his hospital bed. When he finally spoke, he said, "Baby girl, you can't take everyone on this journey you're on. Everyone can't go." At the time, I didn't know what he meant. Of course, I had to learn the hard way. I trusted people with too much access and too much information. Just as people often play a pivotal role in your success, they can also contribute to your failure.

Currently, I have the greatest seven friends on Earth. I have elected to keep my circle tight—very tight. I don't question sharing sensitive information with them because they are all trustworthy. For reference, I don't use the term 'friend' lightly. I remember sitting in a Girl Scouts meeting with my daughter and the leader was teaching the girls how to resolve conflict with new friends. She repeatedly used the term "friend." I politely raised my hand and made a recommendation to not use the word friend so freely. It's more likely the girls will have to resolve conflict with acquaintances, not friends. The process is very different.

Every woman has to go through her closet and do some cleaning in preparation for a new season. The same goes for the new season you are going to walk into when you apply the principles in this book. You need to clean out

your proverbial friend, acquaintance, and relationship closet. As we work on becoming self-aware, people who have our best interest (and not) become clear. My counselor in college would always say, "When someone shows you who they are, believe them because they've known themselves a lot longer than you have." We've all been disappointed and maybe even betrayed (I call it played). The point is to begin to identify people who aren't on your team and remove them. Period!

Let's get **Stratechic** with how you will build your team. First, create a personal board of directors that consists of the following: a chairman of the board, an advocate, an advisor, and a sponsor.

Why are mentors not mentioned? I believe mentor-mentee relationships are a dying breed as they require a greater time commitment and a deeper level of trust. I'm not saying mentors can't be valuable. However, there are other options available to help you achieve your desired outcome. Advocates, advisors, and sponsors are just as effective in most cases and less time-consuming. I receive many requests from people who want me to mentor them and I just don't have the time to allocate to the commitment. However, I can advise, advocate for, or sponsor them. This can and has been just as valuable and influential.

I recently received a call from a good friend and her son wanted an internship at a big entertainment company. I called one of my contacts and asked if she would push his application through the system. I advocated for him because I know he is a good kid and would work hard. He received a call two weeks later for an entry-level position, not an internship. There is power in advocacy and having

a strong board of directors and influencers in your circle. It takes work to stay in touch and in good standing but it has its benefits.

Your board of directors may be different as you pass through different phases in life. In college, your board probably includes your parents, a teacher and a friend.

If you are in Corporate America, your board should consist of a friend/confidant, a peer in the same industry, a leader in the company, an influencer in your line of work and someone who is an influencer in the community. Take some time to think about your board.

What does your current board look like?

The chairman of my board is my husband, Tony. He is my rock and I can count on him no matter what. He tells me the truth whether I want to hear it or not.

My board of directors includes the following:

My current boss is the most senior person on my board of directors. He helps guide my career and makes sure that he is creating an environment where I can be my best self and provide for my family. He also pushes me to make sure that I am always functioning at the highest of my capability. It's critical that you have someone on the inside that will give you real-time constructive feedback and push you to do great work.

Tiffany R. Warren and Bozoma Saint John are my corporate queens. I confide in them and ask for honest feedback about business scenarios. Their opinion is critical

to my growth.

Joy McGowan and Nicole Hall are my truth tellers and prayer warriors.

David Thornton, my brother, is my confidant and conscience.

For your success, you need to surround yourself with people who can help you grow mentally and spiritually. Make it official. Corporations depend on their boards to stay in business, why shouldn't you? Also, remember that as your life evolves, so should your board.

An entrepreneur's board should consist of people in their line of work, similar companies, a close friend, a lawyer, a financial expert and other entrepreneurs.

I have to mention influencers. I love the word influencers. They aren't dictated by title or position. Get to know who the real influencers are in your company, school, church, etc. It's important to know the HR team and every administrative assistant in your department. People can't get to me if they are rude to Brittney. Her title of Executive Assistant does not describe her influence. I would also recommend that you know who pays you and how you get paid. Last but not least, please do not forget the mail room clerk and cleaning staff. They also have valuable information. Don't just walk past them like they don't exist. On many occasions, I have received timely information from both!

Building Your Team: Cleaning out your "Relationship Closet" Exercise (Continuous):

After you build out your board, you also need everyday teammates. Over the next 30 days, recruit the following members:

Advisors (important): People who can give direction and advice. These individuals need to be in positions of knowledge about specific subject matters. When I was writing this book, I reached out to people who had successfully written a book. Lynn Richardson, author of, "Living Check to Monday: The Real Deal About Money, Credit and Financial Security," was invaluable. She told me how to find a publisher, get the book printed and how to sell it. Once I found a great publisher, Renita Bryant (Mynd Matters), everything else fell into place. Egami Consulting Group founders, Teneshia and Mike Warner, also hosted a strategy session when I was laying out the book's framework. It was their brainchild that I should conduct a women's research study. I can honestly say that I would not have finished this project without the advice and direction of these advisors. What do you want to do and who can help you get it done? You have to ask these questions and then do the work to find the right people to make it happen.

Advocates (critical): People who have a seat at the table and use it to benefit others. This is the person who will put you on a list for promotion, agree to be a job reference, make a call on your behalf, select you for assignments that will enable you to grow, and allow you to use their name when necessary. I have had many advocates over the course of my career. One of my biggest is Yvonne McNair (Captivate Management Group). She is the public relations executive for Team *Stratechic*. She ensures that I am considered for speaking engagements and television and radio interviews. She has also pushed me to expand the *Stratechic* brand. Her rolodex and access to the right people has been crucial in

making this possible. I literally keep a rolodex of advocates labeled by their access and willingness to help. These are the folks that I make sure I stay in touch with, send them information that is important to them, know their birthdays, etc.

Make it easy for your advocates to do what is needed to work on your behalf. Ask how you can assist in moving the process along. If you want them to send an email, prepare a draft to save them time. Ensure they know your goals and objective and be sure to send information that will enable them to be successful. The less they have to do, the more likely they are to help you.

Sponsors (important): People who have the power to write checks on your behalf, recommend you for jobs and assignments, add you to promotion lists, and have you added to internal and external training lists. Sponsors see you through the process to completion. I have taken numerous classes, attended seminars across the country and even had an opportunity to attend a women's leadership class at Harvard University. Find out what your company offers and get yourself on the list! Trust me when I tell you that every company has a list of high potential employees they want to see advance and they also have the money in their budget to make it happen.

Elimination List: Who are the people that will NOT grow with you into your next phase of life? People who continue to withdraw time, energy and money and never make a deposit. For them, they need to receive an overdraft notice. These people don't help you grow and want you to believe

that you've already arrived. They take from you and don't push you to be better.

Social Media Clean-up: Every six months you should clean up your Facebook page, especially since it is common for individuals and businesses to use social media as a resource to gather information about potential employees, partners and vendors. Your social media presence is an extension of your résumé. Sometimes 'friends' and connections may post information that you wouldn't want associated with your personal or professional brand. Just as we manage our connections in real life, we have to do the same online. The good news is that it is easy to remove people, posts and unwanted comments as well as make your account private. There are also apps like SimpleWash which allow users to clean up their Facebook accounts based on word searches.

Here are some simple guidelines to follow when it comes to social friends and online connections:

✓ Do not have friends on Facebook that you would not bring to an interview or dinner with your grandmother.

✓ Never put in writing what you would not want to share with your co-workers or family.

✓ Do not post any pictures you would not want printed and hung in the hallways of your job or children's school.

Your social media profile is now part of your résumé and bio. When you apply for a new job or complete an

application for your children to attend a new school, it is an integral part of the consideration process. It's even part of the sourcing for new credit or big purchases. Surprisingly, I've had people Google me while I was in the process of making a sizable purchase.

Once, a friend posted a message to me on my Facebook wall and a random person responded inappropriately. I was about to board a flight so I called one of my board of directors/good friends and asked her to unfriend this young lady. There is no room in my life or on social media for foolishness.

I have also shared this message with my children. They have locked accounts and I approve all of their friends and followers. I also stress to them that they have to be careful about what they post. My son and daughter were goofing around at a friend's house and their daughter videotaped them. My daughter shared the video saying, "Mommy, look how funny!" I politely asked her who filmed the video. After she told me it was filmed by her friend, I explained to both my children to never allow someone to videotape them even when they are just goofing around. They should always own their own content. It's a big lesson for little kids but it is NEVER too early to learn that they have to be in control of their images whenever possible.

In the beginning of this chapter, I mentioned that you cannot afford to have people in your circle praying against you. I have said this at many of my speaking engagements across the country and some women respond with, "that would never happen to me." I will clarify what I mean because it is a very strong statement. Praying against you is

when your girlfriend says she supports your decision to lose weight but does not mean it because she knows she will lose her eating buddy. It is when you are up for a promotion that will move you out of town and although your family seems happy for you, they don't genuinely want you to go. Primarily because you do a lot for them and without you there, they will have to figure things out on their own. You must continually invoke self-awareness when you share information with the people around you to understand who is truly praying for you and not quietly praying against your blessings.

Stratechic Rule #3

RELATIONSHIP BUILDING: PREPARATION + FOLLOW-UP

(120 DAYS)

If you want to go fast, go alone. If you want to go far, go together.

African Proverb

People often ask how have I been able to build great relationships at work and in my personal life. Let me just say for the record that NOT everyone is a fan of Michele Thornton Ghee. I accept that truth because I always walk with several key attributes: transparency, authenticity and integrity. People like to say I keep it real. For me, these are important qualities in building relationships. I've found people respect others that can be honest even when it won't benefit them. I always walk in my true, authentic self. Of course, I will tone it down if the environment is somewhat conservative but I never turn it off completely. Never. People can tell when you aren't being your true self. They feel they can't trust you.

Building great relationships requires planning and preparation. Why do people come to events and not have an idea of the speakers, the agenda, or what they want to accomplish? They don't have a plan for their time. The key to networking is PREPARATION and FOLLOW-UP. Before I go to any event, I research the topics and the panelists. I make sure I set a clear agenda on what I want to accomplish and with whom I want to meet. A *Stratechic* makes contact with the person she would like to speak with a week before the scheduled event. You become memorable and have an instant conversation starter with the person. It seems quite simple but most people don't do it.

I was speaking at an event and a young lady sent me a message via LinkedIn. She introduced herself and asked to meet me before or after the event. She gave a description of what she looked like and told me she would be wearing a pink dress. When I arrived at the event, I was actually

looking for her. Impressive!

Scott Allen, a marketing executive and business coach, says, "Whether you're attending a weekly networking breakfast or an annual tradeshow, planning for a networking event will help you get the most out of that precious little amount of face-to-face time that you get to spend with other business professionals."

Proper preparation consists of:
Knowing who's in the room and preparing to meet those who seem to be a particularly good contact for you (or you for them).

Preparing to make a good first impression. That includes understanding the dress code. I love fashion and expressing myself through clothes. I make sure I know the environment and dress accordingly.

Plan ahead to be stress-free, in a good mood, and arrive in a timely manner.

STRATECHIC NETWORKING TIPS

Business Cards
When I get someone's business card, I jot down notes on the card to remind me of the person. I usually write down what they have on or a unique characteristic. I also place an X if I should follow-up with them. I then scan their business card into my cell phone using the Evernote app. This also allows me to send my contact information immediately. We have to use the resources at our disposal so we can follow-up quickly and efficiently.

Follow-Up

Follow-up is the most important aspect of building relationships. I was speaking at an event and a woman told me she had sent me an email and I never responded. So, I asked her how many emails did she send? The lesson: you may have to send ten emails before someone responds. She had only sent one. Keep in mind, you are reaching out for you, not them. Do not take the lack of response personally. You don't have time to let your emotions get in the way of making a great connection. When trying to build a relationship, follow-up within 48 hours of meeting the person. Key note: DO NOT send a thank you email that includes a request or with your résumé attached (unless they requested it). One of my biggest pet peeves is when I meet someone at an event, they ask for my card and they send a thank you/great-to-meet-you note with their résumé attached. The delete button is pushed faster than a roach scuttles when the lights come on.

If you are trying to develop a relationship, send a thank you note and some relevant information that the person can use. Maybe it's an article about their business or information about a charity they support. If you do your research, you can find out so much about an individual.

Handshake

A Fortune 500 CEO once said that when he had to choose between two candidates with similar qualifications, he gave the position to the candidate with the better handshake. Extreme? Perhaps. But he's actually not alone in his judgment. While analyzing interactions in job interviews, management experts at the University of Iowa declared handshakes

"more important than agreeableness, conscientiousness, or emotional stability." The Daily Muse Editor notes, "Seven other studies have shown that a handshake can improve the quality of an interaction, producing a higher degree of intimacy and trust within a matter of seconds."

A woman's handshake must be firm but not over-powering. Isn't it amazing that we have to pay attention to every detail? The good news is that we are built to pay attention, adjust and self-correct when we need to get better. When shaking someone's hand, face them and look directly at them. Make the person feel as though there is no one else in the room.

Roughly three out of four (74%) women believe networking has been crucial to their overall success. When I started working for a small independent cable network 15 years ago, I remember sending emails and calling people with no answer or returned calls. I had to get creative. I made an investment in custom stationary. I started sending handwritten notes via FedEx with a cute slogan or saying. I would end the note saying, "Isn't this effort at least worth a returned call?" Customize your email with an interesting, eye-catching subject line and a great signoff/signature. Make sure you follow-up every couple of months to check in. Consistency wins in building strong relationships. Plus, it ensures you stay top of mind!

Another tip is to identify what charities or community organizations people support. This is a great way to get involved in something that is meaningful to the people you are trying to win over. Years ago, I heard about The Ghetto Film School, a phenomenal organization that helps aspiring,

diverse filmmakers. Subsequently, the President of our department was heavily involved with the organization. I knew it would be a win-win to volunteer. I'm a huge advocate of giving back to my community and encouraging more faces behind the camera that are from diverse backgrounds. It would also mean building a relationship with an influencer in the company. I served on that board for many years and still today call that executive my friend. He was instrumental in advancing my career and helping me create a very successful multicultural business at the company. Recognize that this strategy only works when you are authentic in your service.

Relationships have been the cornerstone to every promotion, career move, community service project, connection at my children's school, and all the good things that matter in my life and career.

Stratechic Rule #4

ASK FOR WHAT YOU'VE EARNED

(90 DAYS)

"Ask and it will be given to you; seek and you will find; knock and the door will be opened to you."

Matthew 7:7 NIV

I was recently at a conference and had the privilege of moderating a panel with some pow"her" houses. The ladies on the panel were all thought-leaders in their respective fields. Anyone who knows me knows that I hate to follow the agenda or pre-set questions. I looked at my panelists and I asked them, "What have you asked for that you didn't get and what did you do next?"

STRATECHICS, PLEASE PAY ATTENTION!

One of the panelists stated, "I asked for a promotion that I knew I wouldn't get because I was positioning myself for the consolation prize!" Wait. What did she say? She asked for the job that she knew she wouldn't get because she wanted them to offer her a different job? Why would they give her the consolation prize? Because she is talented and they did not want to lose her. However, they were not willing to give her the big job, yet. By asking for the job, she put them on notice. What I love about her strategy is that she did her due diligence.

✓ She found out that the job she had earned was being offered to someone else.

✓ She leveraged relationships for information.

✓ She didn't get angry and quit.

✓ She surveyed her environment

✓ She built a strategy and time-stamped it.

Once she had all of her data, she asked herself, "What can I leverage in this moment to get what I've earned even

if it's not the job that I wanted." Brilliant. I can officially say that she played her hand brilliantly and the consolation prize was actually better than the position she originally wanted. Isn't God good when we get out of our own way and take the time to actually think about all of the possibilities.

Similar to the question I asked the panelists, this chapter is about recognizing and asking for what we've earned. It's about holding people accountable when we don't get what we have rightfully earned. I've seen people promoted or praised for being average. It's the most frustrating thing in the world when you aren't getting the recognition through promotion or compensation and you have no idea why. When we don't know where we stand, why don't we just ask the question? We have to get our power back!

Not many stories stop me in my tracks. However, at one of my speaking events, I met a beautiful, smart young woman. She had been with her employer for over fifteen years and was currently working as a middle manager. She reached out to me to see if I would hear her story and add some insight as to why I think she had not been promoted to a higher level. I occasionally host *Stratechic* sessions with women I meet on the road and I agreed to help her develop a plan so that she could get what she had earned. During our initial conversation, she asked me a question that stopped me in my tracks. "Michele, do you think God has forgotten about me?" The silence between us was deafening. Had God forgotten about her? Wow. First, let me say, I appreciate her transparency. She was thinking it and she cannot begin to build her path unless she is honest about her feelings. I will not go into everything I told her but I will tell you this: God

has not forgotten any of us. He will move in His will and on His time. I ask, "have we done enough to get and keep His attention?" We must remember that God helps those that help themselves. All of the plans that I have put together have been prayed over with the expectation that God will bless the ones that he knows will give glory to His kingdom. My favorite prayer is that God would close any door that was Not for me. It gives me peace of mind to know that any doors left open, are all good. Prayer partnered with a relentless work ethic and a plan is unstoppable.

A few years ago, I worked for a well-respected network for several years. I was not getting promoted although I had performed at a very high level. I served on various committees and even created a new business segment within the company that generated millions of dollars. I thought about the best way for me to position myself for promotion. Sometimes you have to take risks and be prepared to leave, ask tough questions and then be prepared for the answer. I made an appointment with a top executive in the company who could absolutely make sure my promotion came to fruition. We had a strong relationship and I confidently believed he recognized me as a valuable contributor.

Unfortunately, like most executives, he was busy and my promotion was on a list of 500 other necessary tasks he had to complete to run his department. How did I move my promotion up to the top of his priority list? I requested a meeting and asked him a couple of simple questions:

Was I doing a good job?

Was I valuable to the company?

Did he want me to stay?

He replied 'yes' to each of my questions. Then, I came with the unexpected. I asked him, "If the company isn't willing to promote me, will you help me find employment elsewhere?"

My closing line was that I had earned the right to ask him for help and support even if that meant leaving. I was able to articulate my story with concrete data as to why I should be promoted. I was promoted within the year.

It's understandable to be afraid but you have to ask for what you've earned to the right person, with the right data at the right time. Ninety-six percent of the Women & Strategy Research Study participants have had a professional experience where they asked for what they wanted even though they were afraid of the response. Of those that asked for what they wanted, 9 out of 10 had the situation work out either somewhat or completely in their favor. Of the small percent that didn't have it work out in their favor, they still don't regret asking.

There was another young lady who came to me to help her devise a strategy to get promoted. She had been an assistant for five years and had performed beyond her capabilities. She just wasn't getting promoted. Once I heard the details and analyzed her reporting structure, I believed she wasn't promoted because she would leave work at her scheduled time (not early) to get home so she could see her children before they went to sleep. She did this a couple of times each week. They questioned her commitment to her job and worried that if she was promoted, she wouldn't be committed. Sounds ridiculous, doesn't it?

I advised her to ask her supervisor what were the three things she needed to do over the next six months to get promoted. Once you have the criteria in writing, you can formulate a plan to execute your strategy. She immediately sent a recap of their conversation to her manager. She now had the plan in writing. She created a timeline against the action plan. I told her to send an email once a month about her activity against the goals and how she was doing to her boss and copy the division head. I also recommended she have her peers and people she supported send an update about her progress. She stored the feedback and when it was time for her six-month review, she was ready to ask for her promotion and validate why she had earned it. She produced the written criteria that the division head had provided, the monthly progress reports, support from her peers and the individuals she supported, and me supervising the process from the wings. She was promoted and was one of the best Planners in the company.

Of course, there are times that we ask for what we've earned and we may not get it. I met a young lady at a conference and agreed to a strategy session. She shared her story, which is far too long to include. What I will share is that she was smart. I mean really smart. She was caught in a situation not unlike many women. At one point, she and her boss had a verbal agreement about her advancement and future with the organization. However, when her boss was transferred to a different department, she was left with a new boss who did not know her value. When she asked for what she had already earned, the new boss told her that she needed to prove herself again. How frustrating! Finally, she decided

to quit because she could no longer tolerate the corporate politics. Lesson: never leave what you have rightfully earned on the table.

✓ When people make promises or give feedback, get it in writing.

✓ Have your outgoing manager provide you with a detailed evaluation prior to her leaving the department.

✓ Layout all of your contributions and promote them to your boss and higher leadership.

✓ Activate your internal women's group and if you are diverse, your diversity group.

✓ Create your story and share it with key influencers.

✓ Ensure you have a timeline for results.

✓ Ask key stakeholders for feedback in writing.

Always leave on your terms. Never ever quit on their terms. If you want to stay, fight for what is yours. Do not get frustrated (this is when capacity kicks in). If it is time to leave, so be it. If you feel the need, pray that God closes the door not meant for you!

This strategy also works in your personal relationships. There have been many times I've been in relationships and had to ask the question, "What are your intentions and what's the timing to make it happen?" You may not like the answer but at least you know where you stand. If we don't ask, we don't get.

Ask for What You've Earned Exercise (1 Hour):

✓ What job, position, or relationship status have you earned?

✓ Have you asked for it?

✓ Who can give you what you want?

✓ List the obstacles to getting what you want.

✓ Make an appointment or schedule time to speak with the appropriate person that can either give you or help you get what you have earned.

✓ Ask for the success criteria—what will it take to get to the next level.

✓ Set a timeline before you leave the meeting.

✓ Document and send a recap to the appropriate person.

✓ Provide monthly (or regular), written follow-up around your progress against the list/expectations.

✓ Gather peer support and ask them to send you feedback in writing.

✓ Follow-up and ask for what you've earned!

✓ Be prepared to leave if you are not going to get what you've earned within a reasonable timeframe. (professionally and personally)

✓ Determine what you can ask for knowing that you

may get the consolation prize.

Stratechic Rule #5

TURN UP YOUR SOCIAL GAME

(30 DAYS AND BEYOND)

"Social media is the ultimate
equalizer. It gives a voice
and a platform to anyone
willing to engage."

Amy Jo Martin

Social Media has eliminated excuses. Let me get right to the point: you can create content, brand yourself, fight for social causes, etc. There are no limits to telling your story. However, there is one caveat: make sure it doesn't block you from receiving the opportunity of a lifetime. I'll address that at the end of this chapter.

Social media has taken the world by storm. Whether you love it or hate it, it is completely necessary. In all transparency, I don't love it. It is time-consuming and I am busy, very busy. However, I have learned that social media is a valuable tool in my **Stratechic** tool box. While I am no one's social media expert, I know that it is essential for you to have a strategy around your social media presence if you want to brand yourself.

At the very least, everyone needs to have a voice and presence socially. It is not surprising that 74% of the Women & Strategy Study participants have a social media strategy and 81% use social media for their personal brand strategy. At a minimum, most people have a presence on Facebook, Twitter, and LinkedIn. The question then becomes, what is your brand positioning on the different platforms? Most importantly, how do you keep up with the changing landscape?

The first recommendation is to ask yourself what is your goal for using social media. Is it purely social? Is it to communicate a message or build a brand? Once you've identified what you want to do, everything else will fall into place. You can decide what platforms to use, the image you want to portray, the messaging you will send, and how often you will communicate the message.

My goal is to create a social platform that demands women to invest more into themselves than everyone else by using the core pillars of being **Stratechic**. I distribute that message as a reminder that women need to be **Stratechic** about the plans for their lives so they can win.

To accomplish my goal, I need to build a community of followers who embrace these strategies and also motivate them to share the information with their followers. If I can build a village of supporters that have large followings, then my job becomes easier because I can leverage them to send out messaging for me. I can change more lives.

The content has to be relevant, compelling, and released on a weekly basis. Fortunately, I can choose to do it myself or I can hire a company to do it for me which is exactly what I did. I hired a young, **Stratechic** who could manage the day-to-day of my social media demands. She had to understand my life assignment, my voice, and my passion for women. "Ariel the Mogul" absolutely is aligned with my vision and pushes out messages on a consistent basis. We wrote our plan, with the help of my PR executive, Yvonne McNair, and intentionally created a social strategy. Over the last year, I have sold more than 4,000 books and stood on numerous stages. None of this would have been possible without social media and my social media team.

There are a few other important platforms that we have leveraged. LinkedIn has been a great resource and a staple in my social media presence. My profile is regularly updated, I monitor who views my page, and I connect to important people that are in my long-term strategy. Also, I believe that the people I'm connected to have similar interests and are

equally yoked. Through LinkedIn, I've been able to connect with other professionals and source new job opportunities. This platform will be a key tool for the *Stratechic 2.0* book launch as well.

Overall, LinkedIn should tell a story quickly and succinctly. Whether you have a descriptor or your actual title is really a preference. When someone sends me a request, I look at his or her title. Since that is important to me, I decided to list my title first. It's also vital to list all experience, including leadership in the community. I've been asked to speak and been approached for opportunities because of the leadership roles I've held outside of work. I also make sure that all of my information is up to date on all of my social media accounts including recent accomplishments and photos.

Always have a contingency plan if you are ever locked out of your accounts or your data is lost. Make sure you can at least connect with the people you've identified as influencers, potential high-value connections, and personal or professional board members.

Every month, I Google myself to make sure nothing is posted that I did not or would not approve. Another suggestion is to set up Google alerts to monitor if your name is posted or mentioned. You can set up specific words, phrases or sites and get just-in-time updates whenever your name is mentioned.

An app I use daily to help organize my life is Evernote. It's a free application (you can choose to pay a small annual

fee if you would like additional functionality) for your smartphone and computer and stores anything. For example, I store my calendar for my children's school, PowerPoint presentations for meetings, important emails, articles to read, and to-do lists. The app also creates an email address for you so when you need to save an important email or presentation, you simply email the data to your Evernote email address. The best feature is the ability to sync between your computer, smartphone, or tablet. If you're not using Evernote to organize your life, you are really missing out!

Over the next 30 days, make a concerted effort to create or update your social media profile. Ensure your information is up to date including pictures, brand messaging, recent titles and accomplishments. Through social media, you have the ability to control how people perceive you and your brand. You should also have monthly check-ins to refresh your pages and ensure you are telling the most relevant and recent story for where you are at that point in your life and career.

I started this chapter by saying that social media can open up doors OR block you from the opportunity of a lifetime. Everyone reading this book must understand that who you friend on social media becomes part of your résumé and bio. Employers are now scrutinizing what we say, do, and who we hang out with virtually. A few years ago, I was waiting for clearance to hire a young lady I really liked. Companies always perform background checks to make sure a candidate's credentials are factual and that their social media profiles are clean. Come to find out, the young lady had posted some derogatory pictures and comments which

did not paint her in a flattering light. Needless to say, I was unable to hire her.

Another time, I was waiting at an airport and happened to see a Facebook post pop up. A good friend asked me a question in the open forum. Before I could answer, one of my Facebook "friends" answered the question on my behalf. Wait. What! Unfortunately, the answer was inappropriate. I called my friend in Oakland, gave her my passcode and asked her to remove that person from my list of friends. I'm quite serious about who I friend and the online conversations tied to my profiles. I refuse to allow someone else to block me from an opportunity and so should you.

STRATECHIC SOCIAL:

✓ Know your brand.

✓ Use a picture of yourself so people will know it's you.

✓ Keep your profile updated.

✓ Build a village of followers and supporters who can send out messaging on your behalf.

✓ Create a contingency plan if you are ever locked out of your account.

✓ Search your name, set up Google alerts, and monitor your mentions on a monthly basis.

✓ Hire someone to help you.

✓ Don't post anything that can come back to haunt you.

✓ Remove people from you friend list that do not represent your brand.

✓ Use social media to build your platform and your business.

Stratechic Rule #6

EXECUTE YOUR PLAN

(180 DAYS)

"A goal without a plan
is just a wish."

Antoine de Saint-Exupéry

"Vision without Execution
is Hallucination."

Thomas Jefferson

"The perfect plan, poorly executed, will fail. A lousy plan, well-executed, is often successful. It may seem obvious, but the way to fix a failure is often simple: work harder."

Scott H. Young

This is one of the most important chapters. Why? Because a car without fuel cannot go anywhere. The "E" is the gas in **Stratechic**. Execution is imperative. So, what are we executing?

Everything that comes before and after the "E."

How many times have you attended a conference, church event, weight loss session or company meeting and received great advice? You are so excited about the possibility of what's to come because the dynamic speakers on stage were just that good. However, once you get home, nothing changes. I mean nothing! We all know it's easy to hear great advice and strategy but very difficult to implement. Execution needs a few critical components: action, the desire to want something different, allocation of time, consistent follow through and a positive attitude.

You have to take action.

You have to want to change.

You have to carve out time to make it happen.

You have to follow-through with consistency.

When I decided to leave one of my previous employers

because a promotion to manage people was not going to happen but was crucial to my growth, I began to execute a strategy to leave the company. Listen ladies, this happens to all of us. We hate our job, our relationship, or how we look in our cutest pair of jeans. The list goes on and on. Problem is—we don't know where to begin to change it.

You begin at the beginning!

What are the steps I took when I decided to leave an employer that had no confidence in my leadership skills? I decided to no longer work at a place that didn't value my ability or accomplishments. I would rather put my energy into finding a new place of employment that would at least appreciate my talent and leadership.

First, I bought a white board and had it installed in my office. I made a physical list of the possible places I COULD work and another list of places I WANTED to work. I listed the people that could help me make my transition happen. It's amazing what becomes possible when you write out what you want and who can help you get there. I listed the things that were non-negotiable. I considered things like work-life balance, perks and benefits, opportunities to manage people, ability to grow within the company, and overall environment for success. I then transferred all of those notes to an Excel spreadsheet so I could keep track of it on an ongoing basis. Next, I created a relationship map for the possible opportunities. It's amazing how big your rolodex is when you organize it based on the current assignment. I crossed-reference the jobs with folks I knew and enlisted my board of

directors. I updated them on my options and weighed their feedback. I updated my résumé and bio and made sure all of my latest accomplishments were listed on LinkedIn. I put a timeline against the move. Because I developed a strategy and executed against it, I found a great job.

This chapter is important for women because this is where we have to really make a commitment to make time for our life plan and ourselves. We execute plans for our children's birthdays, the PTA, retirement parties, holiday gatherings, summer camps, your pet's veterinarian appointment and then at the end of a long day, we spend 15 minutes thinking about us—what we want to do and what we want to accomplish. Time is to be valued and maximized. It is to be shared smartly.

I did the same thing when writing this book. To execute the completion of **Stratechic 2.0**, I had to identify the topic and a host of other variables, including how to edit and publish. I called one of my advocates and good friends, Lynn Richardson. She had written several successful books and I was confident she could help direct me. She made the execution much easier by laying out the critical elements for self-publishing. Ladies, we don't need to do everything from scratch. We have to tap into our circle of expertise and ask for direction.

I also had to setup my LLC, figure out how to promote and market the book, and meet the timeline I'd set for myself. I implemented the same principles when I was looking for a new job. For you to be reading the second edition of **Stratechic** is a testament that the **Stratechic** framework works!

Stratechic Rule #7

CAPACITY MATTERS IN GOOD AND BAD TIMES

(30 DAYS)

"You never know yourself until the chips are down. True strength is not measured when you're at your strongest, but when you're at your weakest."

Rashad Evans

"What people have the capacity to choose, they have the ability to change."

Madeleine Albright

Research finds that men are not as skilled as women at dealing with more than one problem or task at a time. One study found that, "women preform 70% better than men at juggling more than one task at a time."

Capacity is the ability or power to do, experience, or understand something. Capacity has two faces. The first is to work hard and work smart. It is a given that you have to outwork and outperform your peers. Excellence is the best way to get exposure. Unfortunately, many of us know all too well that outworking your peers doesn't equate to the recognition, promotion or money you deserve. That is when the other side of capacity is crucial:

The ability to endure the feelings that arise when you don't get what you deserve. To mask the feeling of disappointment and anger.

I've spent years playing the game, smiling when I witness average people promoted ahead of me. Instead of letting it get the best of me, I began to think about my options and devise a plan that would help me move up or move on. I became ***Stratechic***.

So, how do you build capacity?

This is why self-awareness is so vital. You must know what makes you stressed and unfocused. You also have to know what motivates you. This is where a vision board becomes essential. Your vision board is a reminder of all the things you want to do. It's a compilation of the goals and dreams that you are motivated to make a reality. This board should be placed in a visible place as a constant reminder that you have work to do. The goal is that the vision board

doesn't just become a piece of art. That's why this book is so important. We must have the capacity and wherewithal to see the vision through to reality.

Capacity comes from a desire deep within. Work ethic plays a role but not as much as wanting to send your kids to the school of your choice, or moving into that new house with the pool in the yard or more like me, snagging a black, Porsche 911 Turbo (I'm going to buy one when my kids go to college).

Let's get *Stratechic!*

Capacity becomes key when you aren't happy with your current situation. When you aren't getting promoted, can't find a job, or your significant other isn't cooperating. Capacity allows you to stay focused when you're in the valley and reminds you to never let people see you sweat. I advise people to always live and leave on their own terms.

When I was considering switching companies, I made sure no one knew how I felt. My attitude, work ethic and delivery never wavered. Why is this important? I continued to contribute to my current job and that kept my skill level on par but also allowed me to leverage my resignation. I left on great terms and to this day, have a great reputation with my prior employers. Of course, I didn't always have this mentality. There were times that I wanted to walk in the door to a job and curse everyone out. You know the feeling. You've probably daydreamed about walking into the office and telling everyone about themselves and then quitting. *Stratechics* feel that way but never let it show. They use that

energy or desire to fuel their next move.

Of all the women that have passed through my office, this is the number one topic discussed. They are angry, disappointed or frustrated and they let it show. The stigma of a bad attitude is difficult to shake. Once you have that reputation, more times than not, you literally have to leave and start over. Don't let anyone or any situation put you in a position of weakness.

A few years ago, a young lady asked to meet with me as she sought my help to get promoted. I really liked her and wanted to help. I knew I needed to have a tough conversation with her because she had a reputation of having a bad attitude. I'm really sensitive when it comes to this label because I know it's often given out unfairly. She was thoroughly frustrated, having been with the company several years and not advancing. Unfortunately, the young lady allowed the frustration to show in her attitude. I explained that she had to turn around the perception and advised her to implement the capacity strategy. Unfortunately, she just wasn't able to get over her anger and frustration and wasn't willing to play the game to get ahead. She didn't get promoted.

The end game is to continue to exercise capacity when things are NOT going your way.

Stratechic Rule #8

HELP OTHERS

(60 DAYS)

"There is an intricate
harmony between doing what
you love and doing it with
meaning and direction."

Brittney Dorsette

"No person was ever honored for what he received. Honor has been the reward for what he gave."

President Calvin Coolidge

I love the saying, "Leadership is not created in the hallways of Corporate America but what you do outside of those walls." When I was NOT given an opportunity to lead people at work, I was able to build those skills on various boards and organizations where I volunteered. I was able to implement strategies and direct people to an end result. My grandmother always told me that if I give from an authentic place, it's okay to get something out of my sincere generosity. That does not mean you should give to get. It means to be smart about where you spend your time, money and energy.

Looking back, it was illogical that one of my early employers, for whom I worked for several years and won numerous awards (internally and externally), wouldn't promote me to Vice President because the company didn't believe I could lead people. To this day, I have no idea how they came to that conclusion. And trust me, I asked. What was the basis for that rationale? I assume they weren't convinced I could have direct reports that would accept my leadership and follow my direction. It's like a credit card—you can't get one until you have one.

Regardless, through community organizations and board participation, I was enabled to lead and manage people. I also led task forces and advisory boards. I chaired an important diversity organization. I was leading and leading and leading. All of that service, my sacrifice, was placed directly on my résumé under the section called

LEADERSHIP.

I won't hire someone that doesn't have some kind of community service listed because I know what skills you must have in order to serve the community, the passion it takes and the humility that's built in giving back.

"At the end of the day, it's not about what you have or even what you've accomplished… it's about who you've lifted up, who you've made better. It's about what you've given back."

Denzel Washington

I will never forget meeting a young lady who worked at the front desk of a Detroit hotel. I always try and speak to the people working at the front desk because that was my job while attending Golden Gate University. It is a challenging job because many of the people that you interact with have little compassion for you as a hotel clerk. As I checked out of the hotel, the young lady complimented me on my outfit and asked where I was going. I explained that I was an author and was headed to speak to a group of church members. She told me that she was at a crossroads in her life and mentioned potentially trying to attend the event. After she asked me about the cost, I told her she could be my guest if she could make it. Long story short, I attended the event, presented my material and then got to the question and answer section. When we got to the last audience question, it came from the young lady from the hotel. When I realized it was her, I told the audience how we'd met and why she was there. I asked her to come forward and as she told her story, tears welled up in her eyes. We all have the power to

see people—really see them. If I had been in a rush, I would have missed an opportunity to change a life. Several members of the audience came up to her after the event and got her number. One women even bought her a copy of my book.

I've built some very valuable relationships from serving on boards, working in the community and now speaking to audiences about *Stratechic*. Those experiences introduced me to people that have helped me in my career and taught me invaluable skills, including my previous boss, whom I served with on the board of Ghetto Film School. I've also met some great employment candidates through service. More importantly, I have been able to encourage others to be their best selves.

Stratechic Rule #9

INVEST IN YOURSELF FIRST

(1 YEAR)

"Excellence is not a skill.
It's an attitude."

Ralph Marston

This is a big chapter for me. I make some admissions in this part of the book that I would have never made until I became self-aware. I needed to understand that I could reflect God's best image–but it would take work, commitment, and sacrifice. I was overweight. I had low self-esteem. I tried to be cool and fit in with the in-crowd. I wanted the most popular man because that made me look better or be more accepted. I did things to make people love me. Basically, I was a mess. Not only did I not invest in myself, I allowed people to make withdrawals on an ongoing basis.

I talked about my dad and how his death was a catalyst for me wanting to be better, but I also have an aunt that I have looked up to for many years. She is a magnificent and brilliant human being. I never really tapped into her bank of knowledge, but I remember hearing her speak and her words stuck with me. Her huge shadow pushed me to want better until this day.

I was probably 18 years old and my aunt, Dr. Shirley Thornton (Colonel Thornton to those who know her through her military service), was being honored. In her speech, she said, "When I would walk into a room, they would first see that I'm black, then a woman, then I'm educated." Never forget that order. Women are judged visually more times than not and have to prove why they should have a seat at the table. It's not far from the old saying that "pretty will open the door, but smarts will get a dinner invitation and beyond."

A *Stratechic* understands that she walks, talks and dresses for the job or role that she wants, not the one she currently holds. So, let's talk about my transition because

it was long and tedious. I didn't wake up looking, speaking and dressing like an executive, author, and empowerment speaker. On my father's deathbed, I made him a promise. They were the last words he would ever hear. I told him that, "he was my hero and that I would make him proud of me." I made a commitment that I would walk in my best self. I had already made so many changes about the people I dated and the friends I hung out with but I needed to make some personal changes. I needed to polish my image. I spoke with an Oakland slang. I was overweight. I dressed to get attention from the wrong people. I wasn't confident in front of people I didn't know.

When I moved to New York in 2000, I decided that I needed to have New York polish, so I hired a voice and diction coach. The woman was in her late 80's. She was a prim and proper woman that served tea and always wore her St. John suit when I arrived for my lessons. The first three lessons she had me repeat my name over and over and over again. She would tell me that there is power in how you say your name "Michele Thornton." She would have me pronounce every syllable. That wasn't easy because of the "N" in Thornton. Yes, she taught me the importance of pronunciation, but the more valuable lesson was teaching me to have confidence when I introduced myself to anyone. I am thoroughly disappointed when a woman stands up to ask a question at an event or conference and doesn't introduce herself with confidence.

I recently spoke at a women's event in Washington DC. A young lady stood up (she was visibly nervous) to make a statement. She didn't say her name but instead said, "Hi,

I'm really nervous because I'm not good at public speaking." Nooooooo! Never ever ever tell people what you're not good at because we would have never known. I asked her to sit back down and start over. I requested that she stand up and say her name, first and last, and then make her statement with confidence. It's a lesson that the women in the room took to heart.

I also knew that I had to lose weight. My weight fluctuated for years. It was up and down based on my love life or happiness with life in general. It was ridiculous. I would go on eating binges and then try and diet. Everyone reading this book knows how easy it is to gain five pounds and how hard it is to lose it. Remember, I moved to New York and made a promise to my father. My success as a sales professional was in part tied to my appearance. I can also confidently say that most women recognize that appearance plays a factor in their careers (research results available in the appendix).

We have to be honest with ourselves and make decisions based on our current environment. Self-awareness plays a big role in how we determine what success looks like. Conforming does not mean selling out. We have to compromise in how we show up mentally and physically. When I decided to work in the entertainment business, I knew I had to make some changes. I had already gone to my voice and diction coach to tone down my Oakland accent. I also needed to lose 30 pounds. That was not as easy as saying my name over and over again.

Anyone who has ever had to lose weight knows it is a commitment that takes complete sacrifice and a change

in habits. People always ask me how I lost 30 pounds and continued to keep it off after two kids and over 20 years? I found two pictures of what I wanted to look like and I carried them everywhere. One picture was of me when I was slim and the other was of one of my favorite African-American models (a girl can and should dream). I implemented a 30-day challenge. If I could maintain healthy eating habits for 30 days, just maybe that would begin to become a habit. I stopped eating bread and drinking sodas. Then, I substituted unhealthy carbs with fruits (only before 2 PM) and vegetables. I still ate brown rice pasta. The most critical components in all of my weight loss efforts were reducing my portion size (I only used small plates for all my meals), setting a timeline against my 30-pound goal (1 year) and consistency. It goes without saying that I exercised a couple of times a week. I still use the 30-day rule to this day. I just turned 50 and I look and feel better than ever before!

For my personal style, I set boundaries based on my current situation. I work in the entertainment business so I am able to express myself through more fashion forward trends. I've also worked in the business for 15 years and have a track record of success. When I worked at a conservative network, I was fashion forward but somewhat conservative in my style. I had conservative staples and pushed the limits with accessories. I love a leather coat and a pop of color. The point is that I love fashion but I also pay attention to the unwritten rules of my current environment. We don't want to give anyone a reason to hold us back especially due to our wardrobe decisions.

I was thoughtful and understood my environment and

path to success. For me to be successful, I have to look and sound like the ultimate professional. I love the saying, "dress and act like the job you want, not the one you have." I see young people in my business and they are adamant about self-expression through hairstyles, clothing, jewelry and approach to business. The marketplace dictates the rules. We can follow them with a few minor exceptions or find a place of employment that will allow us to self-express without growth penalties.

Stratechic Rule #10

CRAFT AND COMMUNICATE YOUR STORY

(45 DAYS)

"I've learned that people will forget
what you said, people will forget
what you did, but people will never
forget how you made them feel."

Maya Angelou

Great storytellers win the business, get the best seat in the restaurant and so much more. We must be able to hone in on our storytelling skills. I made a commitment that I would know my personal story better than I know the brands I work for. Please don't know the company you work for better than you know your own story. I can count the number of times I've met with young women (and men) and they can't articulate who they are or what they do. They fumble around with words that have no meaning. Yet, ask them about their company and they can talk for twenty minutes!

Stratechics create and leverage an "elevator pitch." Your résumé and bio are only part of the story. Social media tells another version of your story. The story we are going to focus on now is when you are standing in front of a person that can influence something you want. If you had someone in an elevator for 10 floors, what would you say? Every *Stratechic* should be prepared to tell and sell her story. 78% of the women we surveyed have a personal elevator pitch. What is your elevator pitch? It's a small window of time to impress someone and succinctly tell them who you are and in some cases, what you want.

Below are my personal and professional elevator pitches:

Pitch for Stratechic

Stratechic is a manuscript that boldly encourages women to think like a woman, plan like a CEO and tap into the strategy she was born with!

My professional pitch: Media Executive

My name is Michele Thornton Ghee and I'm a corporateprenuer in the media and entertainment business with over 15 years of experience. I build unbreakable relationships, am knowledgeable about black culture, live authentically, treat people with respect and give back like I may one day need someone to give to me.

My elevator pitch is written down and I carry it everywhere I go. I practice it in the mirror or in front of my kids. I make sure that I can tell my story at the drop of a dime. Anytime. Anywhere. I update my elevator pitch as often as necessary. You should also have variations of your story based on the situation and your audience. It needs to be agile. The point of crafting your story allows you to sell anything you want, including yourself. Everyone needs to know how to sell as everything in our world is bought and sold. Let's take a quick glance at some important sales characteristics.

In "The Top 5 Reasons Women Make Great Salespeople," Liz Wendling writes:

"Why do so many business women spend more time hoping or praying for sales rather than just learning to sell? Because the mere mention of the word sales brings up fear, dread and anxiety in the hearts of many! In this fiercely competitive economy, every meeting, sales call and interaction with a potential customer is vital to the success of a business. Women must have strong tools in their toolbox to create a long-term sustainable business. What women don't realize is that they were born to sell! Here are five key reasons women make great salespeople:

We are excellent listeners.

Women have a natural ability to listen, which allow us to build trust and gain rapport. Listening for information and clues about the customer—their interest in our products, what's important to them, stories about their children or hobbies—helps with the selling process. Listen to not only what is said but also what's not said.

We tend to be empathetic.

Putting ourselves in the customer's shoes enables us to discover specific details about the customer and how our product or service can help. We find out what's most important to our potential customer, how we can solve their problems, and what features and benefits our product delivers to fit their unique needs. Women's tendency to express their emotions and decode others' emotions allows us to tune in more to a client's needs.

We have strong intuition.

A woman's intuition is considered her sixth sense. Women tend to depend more on it than men do. Women have gut feelings, great antennas, an inner voice, a little nudge that says whether or not to move forward. We can sense things about people and predict if a potential customer is a good fit. Tapping into the gift of intuition provides tremendous value in the sales process.

We multi-task well.

Women are often touted for their multitasking skills. Since we often don't have the opportunity to do just one thing at a time, we've learned to do many. Women can hear several things and have multiple conversations simultaneously. They

can juggle complex business tasks, feed a baby and find lost keys — all without skipping a beat.

We are naturally good socializers.
Most women love to socialize, and they excel at building relationships. Women socialize differently than men because we consciously make time to nurture and grow our personal and professional relationships. We are nurturers by nature, and this gift serves us well in business.

Women have what it takes to be great at sales! Our strengths, nurturing style, passion and intuition, which were previously discounted in the business world, have now taken hold. We can use our natural talents, combined with a little training, to grow our businesses exponentially!

So, go ahead, ignite your self-confidence and come alive. The only limits to what you can achieve are self-imposed. Go sell!"

No matter where you are or what you do for a living, you must learn how to sell. I use my expertise as a sales executive in every aspect of my life. Whether I'm selling Girl Scout cookies with (or for) my daughter, raising money for one of the charities I support, or trying to convince my husband where our family should go on vacation. Sales skills are activated just like superpowers. Women are born with the aforementioned characteristics. We need to embrace and use them to advance our strategies and plans.

I've been placed in many situations that had me pulling out my elevator pitch and scrambling to put my best foot forward. Selling and networking go hand-in-hand. Just like you have to be ready when you are at an event to meet the right people, you have to be ready with your story.

Great storytelling is critical in closing a deal, asking for a promotion, raising money for a charity or even getting a great interest rate on a loan. Roughly 90% of my day is spent storytelling/selling. I may take that skillset a bit too far, but I know how important it is to get what I want. The bottom line is to be a good salesperson, you have to be a good communicator.

There are a couple of things not mentioned that also make a great salesperson. They ask questions and build meaningful relationships. Women are inherently inquisitive. Let's put that trait to good use in getting what we want.

At one point, I was working for the local phone company selling products and services to cities based in northern California. I was having a difficult time with one particular client. He accepted a meeting and during the meeting he kept shutting down all of the ideas I had to improve his business. So, I finally asked a question. Have you ever had a bad experience with this company? What he told me was shocking. The company had turned off his home phone over a very small discrepancy. Relief flooded over me. It's when you finally get to the bottom of a situation that you don't understand, which makes you feel like you just won a marathon. I asked him would he give me an opportunity to be his telephone service and equipment provider at work, if I could resolve his home situation? He said absolutely. The issue was resolved within 24 hours and he became my biggest customer. I could have walked away just thinking we did not have the right product and services, but I felt it was more than that. Therefore, instincts play a big part in success but more importantly, it goes back to asking the right questions.

For the next 30 days, work on crafting your story. Grab a piece of paper and start jotting down what makes you unique, your strengths, your passions and what you want people to remember about you. Also, work on your sales skills: listen, ask questions, and be empathetic.

Finally, practice your story with key influencers in your circle. Ask for real-time feedback. Once you have crafted your story and are confident in sharing it, you are ready to receive all the things you want.

**When you know your story
and can communicate it,
anything is possible!**

Stratechic

STRATECHIC 2.0

Bonus Chapters

STRATECHIC MEN

"A real woman can do it all by herself... but a real man won't let her."

I love the quote, "A woman has the capacity to do it all by herself but why should she." We have to be open to receiving help and feedback from the men in our lives. I will go one step further and say that sometimes, we even need to seek out and ask for help and feedback. If any of you are like me, that is not an easy task. *Stratechics* have to put their pride aside and seek help from whomever has the best information.

I was torn about the direction of this chapter. Should I encourage men to tap into qualities that allow women to be natural-born strategists? Or should this chapter be a call-to-action for men to support women who are trying to juggle everything and encourage them to become *Stratechics?* I decided on the latter. This chapter was written to encourage men to support the *Stratechics* in their lives in every way possible. That means encouraging them to read this book and at a minimum, this chapter. Why? Because it will help men understand the challenges and opportunities that exist when women have enough time and energy to plan for greatness. Trust me, when we reach greatness, everyone in our lives benefits.

At work or in our personal lives, women have to learn how to master their relationships with men. To start, that means knowing where we stand. The Institute for Women Policy Research says:

> *"Women are almost half of the workforce. They are the breadwinner in four out of ten families. They receive more college and graduate degrees than men. Yet, on average, women continue to earn considerably less than men. In 2015, female full-time workers made only 79 cents for every dollar earned by men, a gender*

wage gap of 21 percent. Women, on average, earn less than men in virtually every single occupation for which there is sufficient earnings data for both men and women to calculate earnings ratio."

These statistics tell me we still have much work to do. **Stratechics** know the statistics because they understand that there is power in this knowledge. How do we get men to respect our innate ability to plan and strategize? How do we make them understand we have the ability to build revenue and equity for companies, run and manage teams, and still care for our families? How do we get them to support our work ethic, dreams and goals without them thinking that we are trying to be hard, selfish or manly?

We implement every strategy I've outlined in this book.

✓ We invoke self-awareness.

✓ We make men part of our inner circle.

✓ We ask men to sit on our personal board.

✓ We ask them for what we have earned by using our ability to tell a compelling story.

✓ We never let them see us sweat unless it is necessary.

I tell the story about how the President of our department had no idea who I was when I started working at a popular news organization. I found out the charity he supported and volunteered at the organization. I then became a leader in that non-profit and he had a whole new regard for my ability to lead.

At home, I have to walk in the door and leave my executive status at the front door. I can't completely change who I am because that is too exhausting. We have to make sure the men in our lives accept our accomplishments, support our endeavors and do not demand more time than we have to give so we can still walk in our purpose. How do we make that happen? We have to invoke many of the skills I've outlined in the **Stratechic** 10-step framework. Often, the men in our lives do not realize how much time it takes for us to accomplish our daily routines.

Self-awareness is the most critical component. We have to know how the men in our lives truly view us in our entirety. Once we know this, we know how to keep them engaged and rally them around our efforts. The others are less critical but still important. We have to be able to ask for what we've earned from all of the men in our lives. We have to be comfortable with male relationships and make sure we have boundaries. For example, I never go to dinner with male clients one-on-one. I don't want to send the wrong signal. So, it's either breakfast or lunch.

If we implement every chapter in this book but the men in our lives don't understand our plan and process for execution, we will not succeed. So yes, this chapter is for my **Stratechics** but more so for the men that love, work for and with them. I don't know about Mars and Venus but I do know that we have to figure out how to remove our ego and support one another if greatness is to be achieved. I encourage every woman to let the men in her life read this book, this chapter at a minimum. We have to work together and communicate to win.

STRATECHIC MEN CHECKLIST:

✓ Pray for her

✓ Help her get back time in her day to work on her plan

✓ Leave your ego at the door

✓ Don't take advantage of her inherent nature to do and give

✓ Be her biggest advocate

✓ Invest in her dreams with time and/or money

✓ Give without an expectation to get it back

✓ Don't judge her relationships with other men or women

✓ Encourage her to continue to learn and grow

✓ Give her a little latitude when she comes home tired and frustrated

✓ Tell her the truth even when it feels uncomfortable

STRATECHIC MOMS

"Women can have everything they want, just not at the same time!"

Anonymous

Motherhood is one of the best things I've done in my life. It has definitely been one of the most rewarding. Also, one of the hardest. "Michele, how can I win when I have a family?" is a frequently asked question when I'm traveling across the country speaking to women. The question is asked by women of different backgrounds, generations, and income levels. They want to know how I get everything done. Can they really have it all? I say you can have it all, just not at the same time. How do you win? You set expectations and you compromise. Balance isn't a word that I use often. **Being *Stratechic* is optimizing communication and setting expectations at work and at home.**

When I started my job with my current employer, I knew that I would have a demanding schedule. I was a newly-hired VP of Sales and had a team that spanned across the country. It would require travel and time to build a winning strategy for the network. At home, we had a family meeting around the dining room table and agreed that this was the right job and I had earned the position. We then talked about expectations. We agreed that I would be home at least two nights a week for dinner, I would take the kids to school two days a week, and never miss important events at school and around holidays. This meant that I would have to be willing to be vulnerable and add the kids' important dates to my work calendar to ensure it was clear that I was not missing those events/activities.

My family enjoys a certain lifestyle and this new job meant that everyone had to sacrifice and compromise. As a family, we had to decide what was important at that juncture in our lives. Once I had everyone on board, I felt better about

being away from home because they knew the end goal and the pluses and minuses that went along with that sacrifice.

As a mom, it is important that my family operates as a team. I've been blessed with the best caregivers for my children. I know that God has covered this family because of the babysitters that have crossed our path. Recently, our babysitter of a year informed us that her class schedule wouldn't work with the hours we needed her to watch the kids. I was stressed. My children are the reason for all that I do and their well-being is the most important thing in my life.

It is not BALANCE.
It is COMPROMISE and COMMUNICATION.

I contacted an agency that placed nannies with families and subsequently interviewed a candidate that I liked. My husband and I decided to hire her. During the interview process, I asked lots of questions and one of her answers made me a little nervous. She stated that she and her husband loved to travel. I thought to myself that she would probably not be spontaneous if I needed to expand her hours or if something came up. I wanted to go over some details with her before she was to start and when I called, she didn't answer. She sent me a text that she was unable to call me back until the next day. That was all the confirmation I needed to know she wasn't the right person. I informed the agency she wouldn't work.

The next day, a good friend called and asked if I would sponsor her luncheon as her original sponsor had backed out. I agreed to help her because she is always helping everyone

else. During the conversation, I mentioned needing to call her back to confirm the details because I had a call with an agency to replace my babysitter. She proceeded to tell me that a mutual friend had just let her babysitter go because her kids were starting school fulltime. Well, all I can say is that we hired her and she is a blessing from God. There are so many messages in this story but the main point is that finding a babysitter took a month of time and energy that only a woman can understand.

As a mom, we have to spend time managing many different aspects of not only our lives but others' lives as well. We are the CEOs of running the day-to-day in our homes, the VPs to our husbands, the Executive Directors in our community and Mommy-in-Charge for our kids. There are many occasions that my kids will ask me to take them to school, come to their school play, be the class mom and the list goes on. I often ask them to prioritize their lists and tell me the most important requests. Everyone must make sacrifices. After they outline the important dates, I mark them on my calendar so my job knows which dates are non-negotiable.

Either Be Successful or Have A Family. But Don't Have Neither.

My goal for *Stratechics* is to have both! Our opportunities are vast and if we do not have an airtight plan to become the CEO of our lives, revenue opportunities are lost that can bless our families and communities. On a recent tour stop with the "Motivated Moms," I worked with mothers to develop their life plans. The first thing I had

them do is reclaim time from the people in their lives that are stealing it and haven't earned it. When moms get time back and understand that they have to use a small portion on building out a plan—anything is possible.

I also rely on my husband. We are a team. Communication is the foundation for our family's success. He would tell you that I practice all ten **Stratechic** steps on him on an ongoing basis (lol).

STRATECHIC MOMS CHECKLIST:

✓ Create a shared calendar with your family

✓ Contact the school on the first day to get important dates

✓ Mark those dates on your calendar

✓ Have a family meeting about expectations

✓ Get buy-in from key family members about your goals

✓ Create a family value chart and post it

✓ Bring the kids and family on business trips when possible (mine come on 4 trips a year)

✓ Make sure your job knows your family priorities

✓ Hire a great babysitter (it's worth the investment)

✓ Institute a no-guilt policy

✓ Share your wins with your family so they know how

they contributed to your success

✓ Join a moms group for support

STRATECHIC MONEY

"I'm not going to be the girl who didn't pursue her dreams because she didn't have the money!"

#bossbabe

Wise money decisions allow women the freedom to make significant life decisions. Whether the decision is to walk away from an employer who isn't acting right, care for an elderly parent, have plastic surgery, take a voice and diction class, or leave a relationship that isn't working. Never be bound to anything that blocks your ability to reach your God-given assignment in life because of money. It's something we have complete control over. Back when my husband and I were looking to buy our first house, we both had high-level jobs and were making good salaries. My husband suggested we buy a house that would be covered by one of our incomes so that we could bank the other paycheck as well as have flexibility if one of us ever lost our job. It was one of the best decisions we made. When my husband decided to pursue his dream of becoming an entrepreneur, we had options that wouldn't affect our lifestyle.

People think you need to have a lot of money to hire a financial advisor. That is not true. In fact, if you want to be financially free one day, hire an advisor no matter where you are in the financial process and then you can figure it out as you go—with the advice of a professional.

Pastor Soaries is one of my favorite pastors. In his book, *DFree: Breaking Free from Financial Slavery,* Soaries encourages us to live with "no debt, no deficits, and no delinquencies." Drawing on his years of experience as a pastor, public policy maker, and community leader, DeForest "Buster" Soaries, Jr. gives us vital keys to debt-free living in his groundbreaking and life-changing approach. "The idea that we would be voluntary slaves is offensive to all of our sensibilities," says Soaries. "But when we continue to spend

what we don't have, charge what we don't need, and borrow more than we can repay, then we must call the problem what it is: slavery."

I haven't shared this with many people because it was such an embarrassing time in my life. During my mid-twenties, I had accumulated debt. I spent money foolishly on clothes, entertainment and travel. Trying to keep up with the Joneses, Smiths, Johnsons and whoever else was around. When I decided that I wanted to go back to school, I couldn't afford it. I had a full scholarship and lived with my dad but had amassed so much debt that I couldn't afford to pay my bills. I decided to take the easy way out and file for bankruptcy. That was one of the stupidest things I've done financially. It would have been better to be delinquent and slowly pay off the debt. It took ten painful years to have the bankruptcy removed from my credit. I paid higher interests rates for everything, couldn't buy the house I wanted and had to a leave a $10,000 deposit on my apartment when I moved to New York. Make smart financial decisions because not doing so can cause irreparable damage. It was bad!

Before my dad passed away, my family created a living trust. It detailed his last wishes but more importantly, protected our real estate inheritance from taxation. When my brother and I sold the house my dad had left us, that decision proved to be invaluable. It provided a small financial cushion for our future.

STRATECHIC MONEY TIPS:
(a few things that have worked for me)

✓ Participate in point programs with hotels and airlines.

✓ Consider committing to one airline and one hotel chain to optimize the benefits.

✓ Negotiate your interest rates.

✓ Attempt to keep credit card balances under 50% of the credit limit to help strengthen your credit score.

✓ Only have one credit card.

✓ Look for sales and avoid buying anything full price.

✓ When you get a raise or another source of income, use the additional money to pay off debt, save and invest.

✓ Do a blend of high (one designer or expensive item) and low (discounted) with your wardrobe.

✓ Donate money to people and organizations in need.

✓ Have a financial plan and use a financial planner. The goal is to be debt free, invest and save.

✓ Contribute to your 401K.

✓ Open an Acorns account (an app that invests your spare change).

✓ Create a will (and living trust when appropriate).

✓ Protect your family with life insurance.

✓ Receive paper statements from bills that have a balance so that you can monitor how you are spending your money.

✓ Check your 401K balance and stock prices daily (I use the app on my phone).

STRATECHIC MILLENNIALS

Ilchi Lee

Both inside and outside of corporate walls, there is a lot of discussion surrounding a specific generation—millennials. Millennials are ages 18-34 and have surpassed baby boomers as the largest living generation according to the US Census Bureau. Companies want to understand how to recruit and retain them while brands vie for their attention, consumption and loyalty. Although a lot of money has been spent to understand, connect with, and target millennials, they still remain fairly elusive to many corporate executives and brand managers alike.

Millennials are confident, connected, self-expressive and open to change. They are history's first "always connected" generation. They have all the access in the world through digital technology and social media. Unfortunately, even with all of the advantages and benefits of being born in this time period, millennials have faced growing unemployment and career uncertainty. So, how do millennials win with everything moving so fast, technology changing daily, and an economy that's not producing jobs at the rate they require? Not to mention their desire to find careers that align with life passions and an increased need for constant authentic experiences. How can they win in an environment that may not be set up to deliver on all of those promises?

Stratechically. They must build a plan and execute it.

Millennials should take some time and think about the following questions that relate to career, community and family. Write down the answers and go back to them often to track progress and revise responses as needed. Note:

Self-awareness and capacity are major contributors to this exercise.

✓ What do you want to do?

✓ Why do you want to do it?

✓ How do your parents factor into your life choices?

✓ Do you have an industry or company identified? If so, do you have a company or industry advocate/ contact?

✓ If you want to start your own business, do you have the skills and resources necessary? If not, what is required to be successful? (money, people, equipment, technology, etc.)

✓ Do you have a board of directors? Do you have a network that can enable your success?

✓ What impact would you like to have in or on your community? Why is that important to you?

✓ Do you want to get married and/or have children? What does your family dynamic look like in 5, 10, and 20 years? Where do you live and how do you live?

✓ Are you fiscally responsible?

✓ What is the greatest goal that you would like to achieve – personally and professionally?

✓ How are you managing your presence and brand on social media?

✓ Have you crafted your personal story?

✓ Are you using technology and social media to build relationships?

The good news is that the answers to these questions are within each individual. There are no trick questions. You can determine what works for you and develop a plan to achieve your goals. Also, given the connectedness of the world and how critical it is to establish relationships with others, millennials are well-positioned. No other demographic knows social media better or can locate information via the web like millennials. They have mastered the art of connecting with someone while following up in a matter of minutes. They have power at their fingertips. However, that power diminishes without a plan.

While the world's increased connectedness and always-on environment has many benefits, there are some disadvantages for millennials. Companies, as well as individuals, now have a constant lens into what someone is posting, what someone is doing, and where someone may be going/traveling. Millennials have grown to feel entitled to expanded freedoms of speech and expression, however, it may cause irreparable damage and harm in the long-term. To avoid derailing the path to success, millennials have to invoke self-awareness at all times. Be aware of what you want, why you want it and make life choices, online and offline, that align with achieving your goals.

I have been pleasantly surprised with the response and outreach from millennial women (and a few men). I recently spoke at The Ohio State University for their inaugural Black

Girl Magic celebration honoring women who have gone above and beyond in their life and career. I was awarded the 2016 Change Agent Award. During my keynote presentation, I introduced four pillars from my book: self-awareness, transform your circle, invest in yourself, and ask for what you have earned. The ladies paid attention, took notes, and asked questions. After the event, there was a long line for me to sign books. The most memorable conversation I had was with a young lady who pulled me to the side to get my advice on a big decision she had to make. She explained that her mom and dad had both been doctors and that she was expected to also become a doctor. She asked, "Does 'ask for what you want' also apply to your parents?" Because we didn't have enough time to truly dig into her situation, I asked her to give me a call. When she did, we wrote out what her thought process should be and the steps necessary to figure out a solution. She didn't want to be a doctor. She wanted to be an entertainer. I love these types of interactions!

Millennials must start planning for their future and **Stratechic 2.0** is the guide for every young woman and man who has a dream and passion to be better than the generation of women and men who came before them. It is a tool to help navigate your future. I want to encourage all of my young readers to understand that you have to be honest with yourselves and all of the folks that love and support you. Don't begin your journey by settling!

THE KNOWLEDGE AND BENEFIT OF KINDNESS

(UNLIMITED)

"Do not be deceived; God is not mocked, for whatever a man sows, that [s]he will also reap."

Galatians 6:7 (NKJV)

Stratechic has a silent "K."

In the first edition of ***Stratechic***, this chapter was entitled Karma. As I was writing ***Stratechic 2.0***, something told me to Google 'karma.' This is by no means a religious book however, God governs all that I do and I ask Him to be present in every aspect of my life. My search results showed that karma is not supported by the Bible. Instead, the Bible emphasizes and supports, "reap what you sow." Fundamentally, the principles are the same but I wanted to draw attention to the slight distinction so that I could be obedient and true to my faith. For ***Stratechic 2.0***, the "k" stands for knowledge and kindness instead of karma. I pray you have the knowledge to understand that what you reap is what you will sow. The last piece of our journey is to be acutely aware of Galatians 6:7, *"Do not be deceived; God is not mocked, for whatever a man sows, that [s]he will also reap"* (NKJV).

As we implement our plans and make progress in our lives, we should commit to forgiving (not forgetting) the people that may have done us wrong, lied to or on us, hurt us, tried to block opportunities, not helped us or other women when they had the chance, and every other reprehensible thing in between! My grandmother would always tell me not to share good news until it was completely solidified. She didn't want anyone praying against me or sending out negative energy for what should belong to me.

Also, we must be dedicated to walking with integrity, treating people with respect, uplifting others when given the opportunity, helping the women that are worthy, and advising, advocating, and sponsoring other women on the

rise. I had a young lady ask me why would I share my secrets to success? My answer was, "What God has for me, no one else can have." It's up to me to claim it. That is why I wrote this book. That is why I help so many women. It is why I advocate for others, so they can one day have a job in the media business, just like mine. I truly believe you reap more when you walk with a spirit of kindness and giving. If you read this book and implement the strategies to become a *Stratechic* and not help others, your efforts will be in vain. You will absolutely reap what you sow and it won't be good.

Congratulations ladies, you are well on your way to becoming *Stratechics*. You are creating a plan for your lives so that you can walk in YOUR TRUE ASSIGNMENT!

Stay focused, love yourself, be kind and

LET'S GO!

WOMEN & STRATEGY
RESEARCH STUDY RESULTS

The *Women & Strategy Research Study* was fielded via an online survey in October 2015 among 27 successful women ages 18-65. The women work across various industries and levels and represent every racial group. A summary of the study follows:

1. There were 3 common themes from the women's definition of STRATEGIC:

 • Have clearly defined goals that you work toward

 • Have long-term vision and intentionally plan

 • Don't focus too much on the short-term

2. Roughly half of the women proactively seek feedback about strengths & weaknesses once a month or more. 80% proactively seek feedback at least once a quarter.

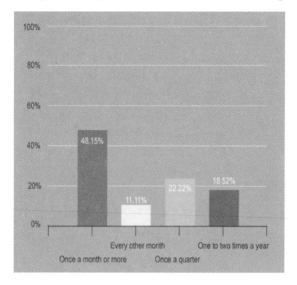

3. 96% of the women said self-awareness has played a crucial role in their personal and professional

accomplishments. Of the tools they use to be more self-aware:

- Over 96% use relationships with others

- 89% use spiritual/work involvement

- 85% solicit feedback directly

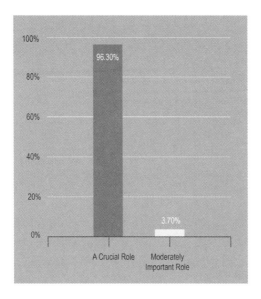

4. The women currently have a: (Note: participants were allowed to select multiple responses)

- Sponsor 56%

- Mentor 3%

- Advocate 74%

- Advisor 85%

5. Less than half (44%) of the women believe having a mentor was very important to their overall success.

6. Less than 4% of the women believe networking had little to no impact on their success. Three out of four (74%) believe networking was crucial to their overall success.

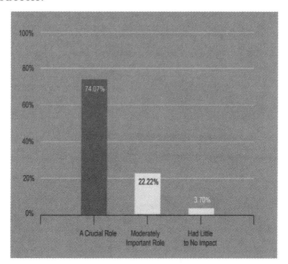

7. 67% of the women have a unique approach to networking. Of those women, they overwhelmingly list "relationship building" and "creating meaningful connections" as the secrets to their approach.

8. 78% of the women have a personal elevator pitch.

9. 59% believe their looks/appearance has played an important role in their success and career progression. 63% of the women have been in a position where they know their looks/appearance enabled them to advance faster and 67% believe looks/appearance should be a factor in someone's success.

10. 96% have had a professional experience where they asked for what they wanted even though they were

afraid of the response. Of the women that have asked for what they wanted, 9 out of 10 had the situation work out either somewhat or completely in their favor. Of the small percent that did not have it work out in their favor, they still do not regret asking.

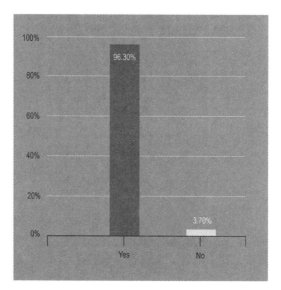

11. 93% of the women believe their professional career has given them access to their purpose as well as better define and translate it.

12. Roughly 1 out of 5 of the women allowed someone or something else to dictate their current roles while over 74% (3 out of 4) either created their current roles based on what they believed it should be or altered it to better fit their strengths and vision for the organization.

13. 74% have a social media strategy and 81% use social media for their personal brand strategy.

Find additional information on Michele Thornton Ghee & *Stratechic 2.0* at

WWW.STRATECHIC.COM

You can also get to know the author better and interact with other *Stratechics* by joining her online community!

@Stratechic

NOTES

NOTES

NOTES